W9-AUJ-935

PERSPECTIVE
For Painters

PERSPECTIVE
For Painters

Howard Etter

Margit Malmstrom

Watson-Guptill Publications/New York

I'd like to thank my teachers, Salvador De Rigil, Thomas Leighton, and Richard Stevens, Sr., for being such effective links in the chain, as well as my students at Lawrence Institute of Technology for enabling me, in turn, to pass this knowledge on. And special thanks to my wife, Martha, for hanging in there and to whom this book is dedicated.

H.E.

Copyright © 1990 by Howard Etter and Margit Malmstrom
First published in 1990 by Watson-Guptill Publications, a division of BPI Communications, Inc., 1515 Broadway, New York, N.Y. 10036

Library of Congress Cataloging in Publication Data

Etter, Howard
 Perspective for Painters / by Howard Etter and Margit Malmstrom.
 p. cm.
 Includes bibliographical references.
 1. Perspective—Technique. 2. Painting—Technique.
 I. Malmstrom, Margit. II. Title
NC750.E86 1990
 90-30264
 CIP
 ISBN 0-8230-3999-4
 ISBN 0-8230-3998-6 (pbk.)

Distributed in the United Kingdom by Phaidon Press Ltd., Musterlin House, Jordan Hill Road, Oxford OX 2 8DP
Distributed in Europe, the Far East, Southeast and Central Asia, and South America by RotoVision S.A., 9 Route Suisse, 1295-Mies, Switzerland.

All rights reserved. No part of this publication may be reproduced or used in any form or by any means--graphic, electronic, or mechanical, including photocopying, recording, taping, or information storage and retrieval systems--without written permission of the publisher.

Paperback Edition
First printing 1993

Manufactured in Malaysia

1 2 3 4 5 6 7 8 / 99 98 97 96 95 94 93

Howard Etter is a painter and freelance architectural delineator and design consultant. He received his training at the Art League of California and the Academy of Art, both in San Francisco. After working in the commercial art field for a number of years, he taught architectural rendering, basic design, freehand drawing, watercolor and acrylic painting, life drawing, and perspective for architects at Lawrence Institute of Technology in Michigan. He has also conducted private classes, seminars, and demonstrations in watercolor landscape painting technique.

Mr. Etter has exhibited his work regularly for some thirty years. He is currently represented by several galleries throughout the country. His work is owned by many private collectors and is in the permanent collection of The Butler Institute of American Art in Youngstown, Ohio. He is listed in *Who's Who in American Art, Artists in Michigan in the 20th Century,* and *Who's Who in the East.*

Howard Etter and his wife live in Camden, Maine.

Margit Malmstrom, who put Howard Etter's knowledge into words, lives in Lincolnville, Maine. In her previous life as a New Yorker, she was an editor, writer, and sculptor, contributing articles to *American Artist* magazine and working on numerous books in the art field in addition to running her own sculpture studio. She collaborated with James Craig on *Designing with Type; Production for the Graphic Designer;* and *Phototypesetting: A Design Manual.* She is also the author, with Bruno Lucchesi, of three other books on sculpture technique: *Terracotta: The Technique of Fired Clay Sculpture; Modeling the Head in Clay;* and *Modeling the Figure in Clay,* all published by Watson-Guptill Publications.

Margit Malmstrom is listed in the *Dictionary of American Sculptors.* Since she moved to Maine in 1986, her sculpture has evolved from studio pieces into the construction of a house that grows by accretion, as well as the long-term "modeling" of the landscape itself.

CONTENTS

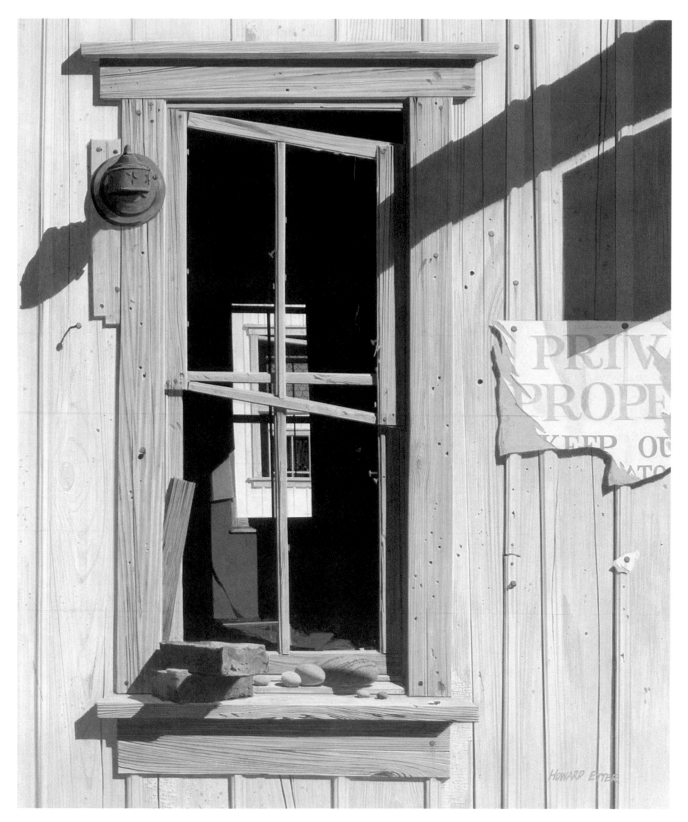

MADRID WINDOWS, *egg tempera on
gesso panel, 24" x 18" (61 x 46 cm).*

INTRODUCTION

More and more artists are returning to, or in some cases continuing in, the tradition of visual realism—and as anyone who has ever tried to paint realistically knows, perspective is the very underpinning, the skeleton, on which the composition will stand or fall. Unfortunately, today's realist painter is heir to an interrupted tradition. The rich heritage of knowledge, methods, and materials that embody the art and skill of creating realistic visual images is no longer being passed intact from one generation of artists to the next. The chain has been broken, and it's a break that has been exacerbated by the modern mandate for individuality at any cost. So perspective, along with a lot of other useful information, is no longer taught as a matter of course. Students are not even aware that they may need it. On the contrary, there are teachers who actively discourage their students from using perspective techniques as being somehow inhibiting to creativity. Nothing could be further from the truth! It's *not* knowing how to control the spatial elements on the painting surface that is the true inhibitor of creativity. Technical skill, of whatever kind, need never dominate or intrude upon the other values in a work of art. Perspective, when skillfully handled, shouldn't even be particularly obvious. It's just that the painting will seem "right," which will allow the viewer to give it the undistracted attention it deserves. And, as with any skill, once perspective is mastered, it can be played with, distorted, even thrown out altogether in order to create specific, intended effects.

This book, then, is for those who, for one reason or another, never learned the rudiments of perspective and now find themselves at a loss; for those who have tried to teach themselves but were intimidated by the technical diagrams they found in books; and for those who already use perspective in their work but would like to improve and expand their skills. Most of all, this book represents one small attempt at mending the break in the chain.

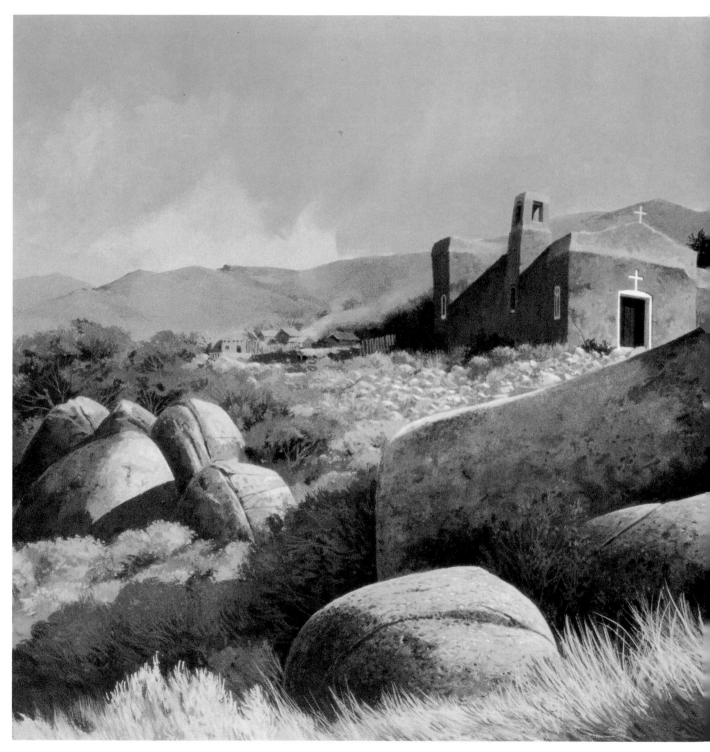

CHURCH AT GOLDEN, *acrylic on
canvas, 18" x 24" (46 x 61 cm).*

Part One
THE BASICS OF PERSPECTIVE

HOW WE SEE

Our seeing is composed of a multiplicity of visual cues that are instantaneously processed by the brain. One visual cue is that objects close to us appear larger than the same objects far away. This seeming diminution of objects as they recede enables us to judge the distance between ourselves and the objects in our environment as well as the distance between one object and another.

The way we see is also affected by the position of our eyes. Although both eyes focus simultaneously, each eye receives a slightly different image, which, when fused by the brain into a single image, results in our perceiving the image in depth. Seeing in depth is of more concern in still life and figure painting than in landscape painting because, at distances greater than several hundred feet, the image received by each eye becomes nearly identical, and visual depth perception is lost. Depth perception includes our seeing the atmosphere itself—haze, particles of dirt, moisture in the air—which can obscure sharp vision at certain distances.

In addition, the familiarity and uniformity of manmade objects—as well as their size and recurring right angles—provide us with constant visual information that helps the brain keep track of its surroundings.

But how do we organize the things we see so that we're able to transfer them onto a flat piece of paper or canvas? Three major aspects of how we see come into play here: *light*, which defines the shape, depth, and location of what we see; *cone of vision*, a mental construct that reveals how much of a subject we can include in the picture without distortion; and *viewing distance*, which is the distance between observer and picture surface and which gives us the size of the painting, the angle of view, and the relationship of subject to picture format. When we begin to paint, these are the three basic guidelines that help us organize what we see.

LIGHT

Why does an object close to us look larger than the same object farther away? Why does the near end of a house look larger than the far end? We know that the objects are the same size and that the house has the same dimensions all around. What is it that makes things appear smaller as they recede in space? It's simply that the light that defines them and streams toward our eye takes up more or less space in our visual field, depending on how great a distance it has to travel.

Light is a form of radiant energy, composed of tiny particles emitted from a luminous body, such as the sun, a candle flame, a lightbulb. Light is never still; it streams outward from its source in all directions. This streaming effect can be imagined as many straight lines, or rays, each describing the straight path of an individual particle of light. As these particles of light move outward from their source, they strike whatever stands in their way. They bounce off some surfaces, are absorbed by other surfaces, and, in general, ricochet all over.

The only reason we can see at all is that some of this streaming, ricocheting light enters our eye. Everything we see is defined by the light that hits it and then streams toward and into our eye. When you stand in a given place and look at a particular scene, your eye receives only those particles of light that happen to be heading in your direction. You can see rays of light that are going in other directions, such as light that streams to earth through a break in the clouds or light that slants in through a window, but the actual shape and depth of what you see is defined by the light that enters your eye. This is why you can see a thing or a scene from only one particular point of view at a time. It's being defined for you by a specific set of light rays. If you were to change your position relative to your subject, different rays would enter your eye and you would see your subject from a different point of view.

Light, streaming outward from the sun, reaches the earth as an infinite number of parallel rays, which can sometimes be seen when the air is filled with dust or moisture. Whether visible or invisible, these light rays moving through space are what enter the eye and make vision possible.

In perspective drawing, we can't follow the path of every single particle of light. We have to choose only those paths of light that will help us define our subject. Any path of light in our field of view may be selected and drawn, regardless of its angle through space, but the paths of light that come directly from an object to our eye are the ones that will become the key lines in drawing what we see. We call these our *lines of sight*. If you think of these lines of sight as threads, each one stretched tight between your eye and various key corners and points of your subject, starting at a tiny point within your eye and widening out in a circle that gets bigger and bigger the farther away the threads extend, you'll be able to visualize what we call the *cone of vision*. In the exact center of the cone of vision, stretching straight from your eye to your subject, is your *main line of sight*.

Once we can trace the path of individual particles of light, we're able to plot the points where these paths of light strike our theoretical picture plane as we plan our composition. If we can do this for a number of light rays coming from various objects and various points on the objects, we'll be able to locate reference points that will allow us to construct a drawing with the same ratios in terms of heights, widths, and perspective depths as the original subject. In other words, by learning to plot our lines of sight, we'll be able to replicate what we see almost exactly.

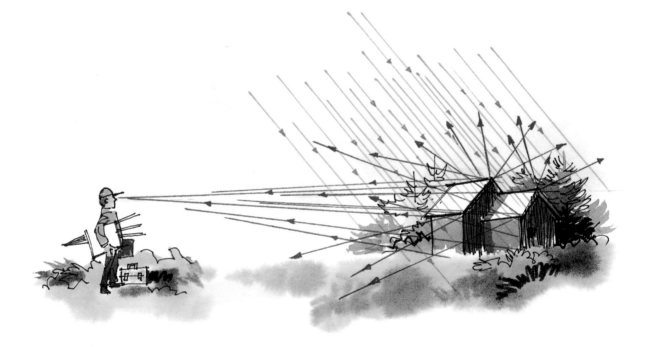

Light rays from the sun are parallel, but when light strikes an object, the rays bounce off in all directions. Some of these bouncing light rays reach the eye to form a visual image.

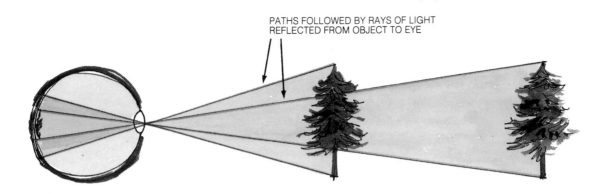

*Because light rays travel in straight lines, a distant object produces a smaller image
on the retina of the eyeball than a nearby image of the same size.*

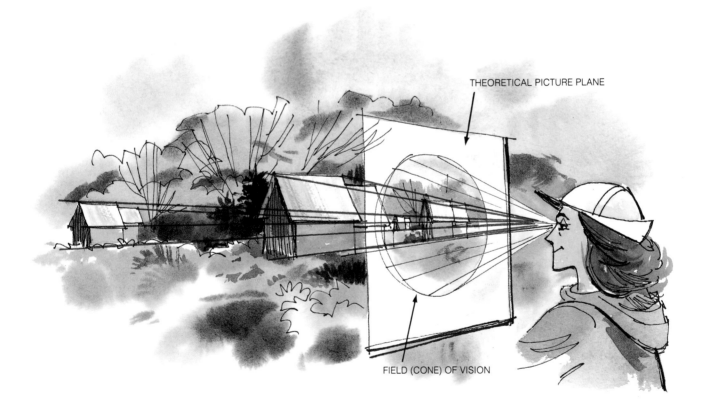

THEORETICAL PICTURE PLANE

FIELD (CONE) OF VISION

*A nearby object fills more of your field of vision, making it appear closer than a
more distant object, which occupies a smaller area within your visual field.*

CONE OF VISION

Imagine a megaphone pointing straight out from your eye. This is your *cone of vision*. The cone of vision is that area of vision, expanding outward in the shape of a cone from its point of origin in the eye, that you can see from one position without moving your head or your eyes too much. It extends, in theory, to infinity but in practical terms only until it hits—or is bisected by—the theoretical picture plane. There it forms a circle of relatively clear vision. Any part of a subject that falls outside this circle will tend toward distortion. If you extend an imaginary line straight from the center of the circle back through the middle of the cone of vision to your eye, you have drawn the *main line of sight*. The small area of sharpest focus around it is the *center of vision*. The cone of vision, and therefore the main line of sight, is *always* perpendicular to the picture plane.

The cone of vision is, of course, a mental construct, a tool to help determine how much can be included in a painting before the edges are lost in distortion. Using this concept helps to set visual limits. Although the human eye is capable of seeing everything within a 180-degree arc, most of this vision is peripheral. The field of moderately sharp vision starts at around 45 to 60 degrees, becoming increasingly sharp near the center,

when the narrowest part of the cone is used. The area of truly fine focus, the area of the cone in which you read a single printed letter, is only about 1 degree.

Anyone who has ever tried to draw an interior scene while standing in the room realizes how difficult it is to know where to stop, where the edges of the picture should be. The eye travels around the walls, the head tilts back to take in more and more of the ceiling, and before you know it, you're lost. Working with the idea of the cone of vision allows you to know exactly what the limits of your field of view are. It acts as a mental frame to keep you focused only on what's right ahead of you and within a range of clear vision.

By assuming a wider angle for the cone of vision, you're able to cover a larger area of your subject. But increasing the angle of the cone of vision also increases the amount of distortion that occurs at the edges of your visual field. In some subjects, this may not be a problem, but the artist needs to know when and where it might be. Some artists use distortion intentionally, as part of their work, whereas others are ambushed by distortions that creep in uninvited. It's up to each artist to decide just how much distortion is acceptable and appropriate for a given painting.

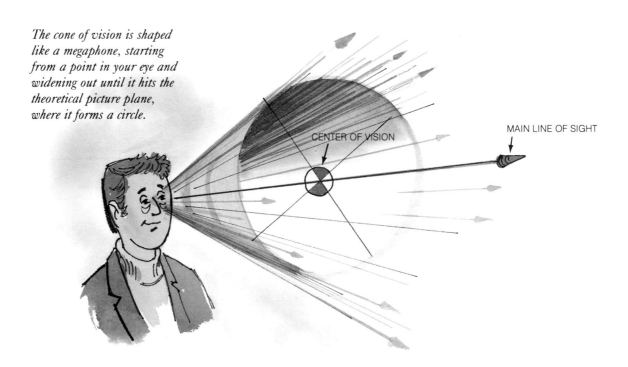

The cone of vision is shaped like a megaphone, starting from a point in your eye and widening out until it hits the theoretical picture plane, where it forms a circle.

CENTER OF VISION

MAIN LINE OF SIGHT

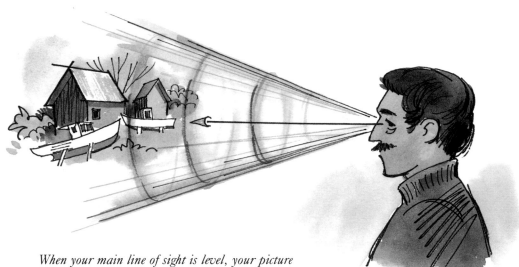

When your main line of sight is level, your picture plane will be vertical, and the vertical lines in your picture will not converge.

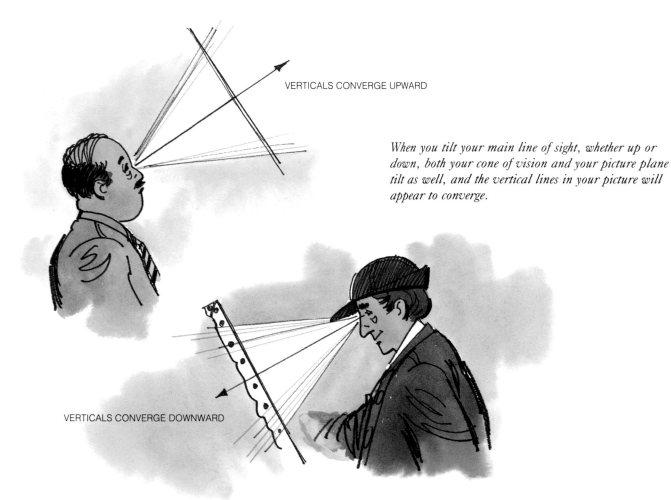

VERTICALS CONVERGE UPWARD

When you tilt your main line of sight, whether up or down, both your cone of vision and your picture plane tilt as well, and the vertical lines in your picture will appear to converge.

VERTICALS CONVERGE DOWNWARD

VIEWING DISTANCE

The viewing distance of a work of art is, simply, the distance from which it will be viewed when it's finished. Ideally, a painting will be viewed from the same distance at which the artist painted it, so that the perspective cues will be seen as they were intended.

Any realistic painting that uses perspective is most convincing when viewed from the distance from which it was drawn. All the lines of sight will converge at this point, and from this point only will the field of vision be comfortable. In other words, the distance between viewer and work should be the same as between artist and work.

Fortunately, when people look at a painting hanging on the wall, they naturally move in toward it or back away from it until they locate the spot where it snugly fills their cone of vision. If the painting has been planned properly, this will also be the spot where the lines of sight converge in the eye. The difficulty arises when the viewer *cannot* get into the right spatial relationship to the painting. This happens when a large painting is hung in too small a room, or a painting is hung too high or too low, or a small work is placed so that the viewer is prevented from approaching it. This may sound like a problem of hanging rather than something the artist should worry about, but it's important that you think ahead about where and how a work is likely to be placed so that you can plan the perspective and format accordingly.

Another difficulty in establishing the proper viewing distance occurs when the painting itself demands conflicting distances. If the painting as a whole calls for a wide field of view, for example, while elements within the painting call for a narrow field, both demands cannot be met from the same viewing distance. This happens when the artist neglects to establish and stick to a single point of view while painting. Just as you can see a thing from only one point of view at a time, so, too, a realistic painting can have only one point of view at a time. The viewer must be able to "read" the entire surface of the work from one position. This doesn't mean that you won't move into your surface as you paint, or that the viewer won't move up close to look at details, but you should always remember to move back to your established station point when plotting lines of sight and vanishing points, just as the viewer will move back to the optimum viewing distance to savor the painting as a whole.

There is, of course, some leeway in the ideal viewing distance, since the human eye can generally accept distortion and still read an image correctly. As long as the viewer is somewhere near the right spot, the perspective will work. It's only when the viewer cannot even approximate the artist's original relationship to the painting surface that the perspective effects are lost. To the extent that you're able to do so, it's definitely worthwhile for you to plan for the eventual viewing situation of any given work. No matter how accurate and convincing your perspective is, if it is seen from the wrong distance or angle, it can look all wrong.

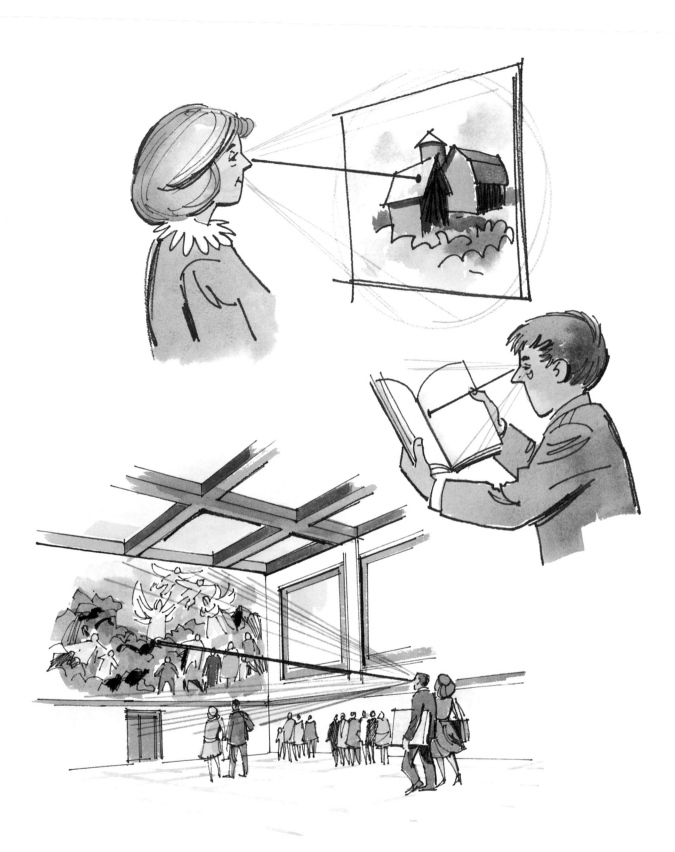

We adjust our viewing distance to accommodate what we look at, moving closer to bring a small format into the narrower part of our cone of vision and stepping back to provide a wider angle of view for a large format.

Two
PERSPECTIVE TOOLS

Getting what you see down on paper or canvas involves imitating visual cues in order to create the illusion of depth on a flat surface. In doing this, you'll have some concrete tools to work with, which, when used correctly, will always produce the effect you want. These tools are the *picture plane*, which allows the viewer to see depth *as if* it were flat and a flat surface *as if* it had depth; the *station point*, which defines the point of view of the picture; the *eye level / horizon line*, which gives the viewer the angle of view up or down, the spatial relationships within the picture format, and the location of the vanishing points; and the *vanishing points*, which give you the angle of view in terms of width and allow you to plot lines that go back in space.

When used together these basic tools of perspective will enable you to transfer what you see in front of you onto a picture surface so that someone else will be able to see the scene as you saw it. The little something more you give your painting results from how you feel about the subject or a bit of invention you may add, or a piece of reality you may remove. In short, what *you* wish to communicate.

PICTURE PLANE

The term *picture plane* applies both to the working surface and to an imaginary, or *theoretical*, surface that we interpose between our eye and the subject matter. The idea of your working surface as a picture plane is easy to grasp: there it is, in front of you, a flat (*plane*) canvas or paper of a particular size and shape. The theoretical picture plane, because it's a hypothetical construct, is perhaps not as easy to understand.

If you could see the theoretical picture plane, it would be a wafer-thin transparent rectangle (or any convenient shape) located in space between your eye and whatever your eye is focused on. It would be exactly perpendicular to, and centered on, your main line of sight.

Artists working in the realistic tradition—in which art seeks to re-create reality, including the depth perceived by the human eye—imagine the picture plane as a *transparent* surface through which they can see into infinity.

The theoretical picture plane serves as a stand-in for the actual picture plane: if you can figure out how objects relate to one another and recede in space on this make-believe surface, you'll be able to transfer what you see onto an actual surface—in other words, translate the real depth you see into terms that a flat surface will accept, then transfer this translation onto another flat surface, this one real, which gives an accurate re-creation of the original depth perception.

From a compositional point of view, the picture plane is the painting surface, the "plane" on which the "picture" is executed and on which the arrangement of shapes and spaces is of primary consideration.

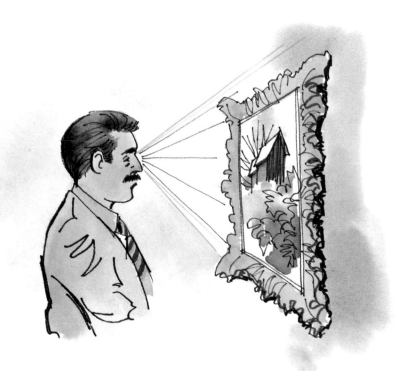

This theoretical picture plane can be located at any distance from the eye that you find convenient. Imagine it as slicing through your cone of vision as it widens outward from its point of origin in your eye. It can slice through at any point, from close to your eye, where the cone is narrow, which will result in a small picture plane, to far away from your eye, where the cone is wider, which will result in a larger picture plane. The most natural distance is the point at which the theoretical picture plane is the same size as the actual picture plane. In this way, you can see both picture planes from the same implied distance and can transfer size relationships and lines of sight directly from the one to the other.

Also, you'll be establishing a distance from which the finished work should be viewed that is identical to the distance between you and your working surface. This means that vanishing points, line of convergence, and other perspective cues will be seen by the viewer just as you see them when you draw.

Most freehand artists carry their theoretical picture plane at a convenient distance from the eye, somewhere from between two to eight feet. This represents the range at which you can comfortably get close to and back away from the working surface. It should be more than adequate to satisfy most picture formats, from small drawings to large easel paintings.

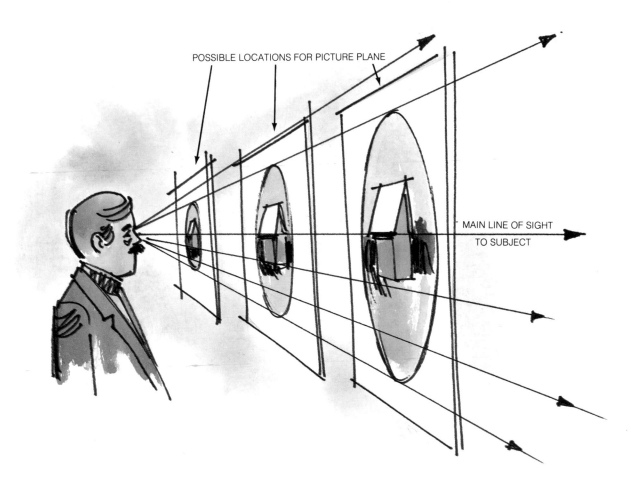

POSSIBLE LOCATIONS FOR PICTURE PLANE

MAIN LINE OF SIGHT
TO SUBJECT

No matter how close to the eye the picture plane is located, the converging lines of sight will produce the same perspective image. The closer picture plane slices the cone of vision where it is narrower, resulting in a smaller format. The more distant picture plane slices across a larger portion of the cone of vision, resulting in the same image but in a larger overall size. Heights and widths within the picture area retain the same proportional relationships to one another, regardless of the format.

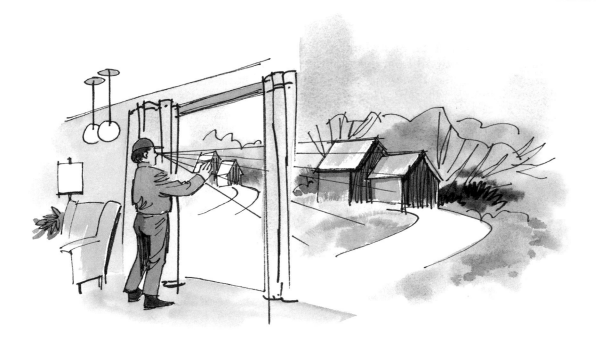

Perspective is largely based on the fact that if you stand at a window and carefully trace what you see through its transparent surface, right on the glass itself, you will produce a realistic drawing.

The artist attempts to do more or less the same thing on canvas—we draw the image we see before us in realistic scale and proportion, as if it were seen through the transparent glass of a window.

STATION POINT

For the freehand artist, *station point* refers to where you're positioned while you paint. More precisely, however, your station point is where your *eye* is. The spot on which you're actually standing is called the *stand point*. This distinction matters only when it's necessary to show both points, such as in mechanical work or in diagrams. For our purposes, only the station point is relevant.

The station point, since it's actually your eye, is the origin of your cone of vision; it's the point of convergence of all the lines of sight that define what you see. It's your station point, relative to your subject, that is responsible for the feeling of depth in your painting. Because the freehand artist usually carries the theoretical picture plane at a given distance from the eye, it remains constant; it's the distance between the station point and the subject that changes, depending on how far away or how close you are to what you're

painting. What this means is that when you move back from your subject, taking your theoretical picture plane back with you, the subject will occupy a smaller area in your field of view and thus appear to be farther away. Conversely, if you move closer to your subject, again taking your theoretical picture plane with you, the subject will fill a greater area in your field of view and so will appear to be close. In neither case has the subject really changed in size; it's only the subject's relationship to the space around it that has changed. The vanishing points on your imaginary picture plane don't change either, but the feeling of near or far does change, and with it the feeling of depth in your painting.

Once you've decided on your station point, it's important to remember to stick to it. Just as we can see a thing only from one point of view at a time, your painting, too, can have only one point of view if your perspective is to be convincing.

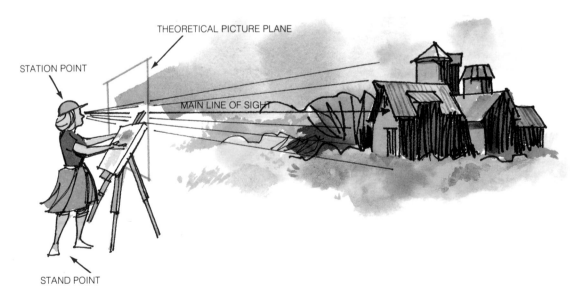

The station point is where your eye is—actually or theoretically—relative to your subject and your working surface. For the freehand artist, it's easiest to think of the station point as the place where you *are, the "station" from which you study and draw your subject.*

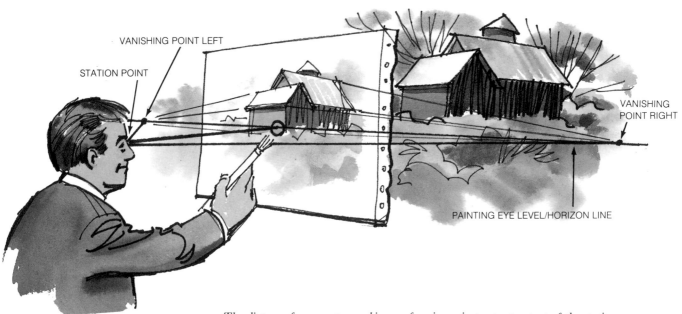

VANISHING POINT LEFT

STATION POINT

VANISHING
POINT RIGHT

PAINTING EYE LEVEL/HORIZON LINE

The distance from eye to working surface is an important aspect of the station point: It's this distance that determines the spread of the vanishing points and thus the ultimate viewing distance of the picture.

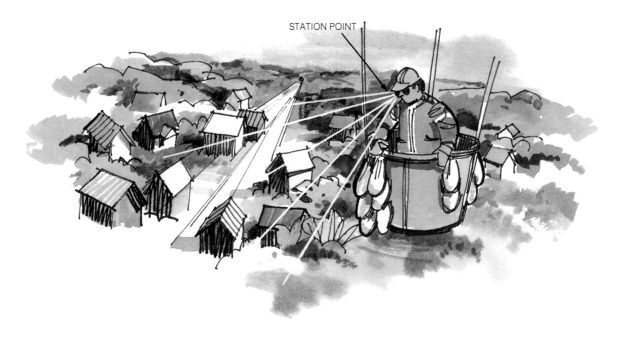

STATION POINT

Even if you were to hover over your subject in a hot-air balloon, your eye would still be the station point from which all your lines of sight would originate.

EYE LEVEL

Your eye level is the height of your eye relative to the ground plane, extended to infinity. Imagine a flat disc radiating out from your head at eye level. In whichever direction you turn, the edge of this disc slices through what you see. If you move—climb a hill, descend into a ravine, stand up, or sit down—your eye level moves with you. But if you move your eyes or your head up or down, changing your angle of view, your eye level does *not* change. *The eye level is always parallel to the ground plane*, no matter what your angle of view is.

Although theoretically your eye level extends to infinity, in fact, because we live on a large planet and not a tiny asteroid, an unobstructed view will give us an eye level and a horizon line that are one and the same. We see this clearly when we look out over a large body of water or any surface flat enough to allow us to see all the way to the farthest rim of the earth, to the "line" where it curves away from our sight. Although there are some instances in which we can see, and thus use, the earth's horizon line as our eye level, in far more cases we cannot see the horizon line and must rely on our eye alone to plot the eye level.

In a painting, it's the location of the eye level relative to the subject that indicates your—and the viewer's—position in space. A high eye level places the observer's eye above the subject, whereas a low eye level places it below the subject. What we call a medium, or normal, eye level falls somewhere in between. In using these terms, we refer to perspective relationships only. From a compositional point of view, the same terms refer to where the eye level/horizon line is located on the picture format, whether near the top, the bottom, or somewhere in the middle of the painting. It's possible to have a high-eye-level format, in the compositional sense, but by placing the subject above the observer's eye level to have a low-eye-level point of view in the perspective sense. When used in contrast like this, the perspective effect will be somewhat diminished. When used together, that is, high compositional eye level with a high perspective point of view (or low with low, or medium with medium), the visual effect is amplified.

Beyond a certain point, your angle of view up or down becomes so extreme that your eye level will be right off your picture format. This means that your picture plane is no longer vertical, and consequently the vertical lines in your subject will no longer be parallel to it and so will go back in space to converge in vanishing points. In absolute terms, any time you're not looking straight ahead at your subject, your verticals will be slightly off plumb. But this effect is usually so minimal that it's best to ignore it and treat all verticals as if they are truly vertical. The human eye seems to be made uncomfortable by verticals that are only slightly off plumb, reading them as mistakes, but it can accommodate verticals that are obviously off and converging in a distant vanishing point.

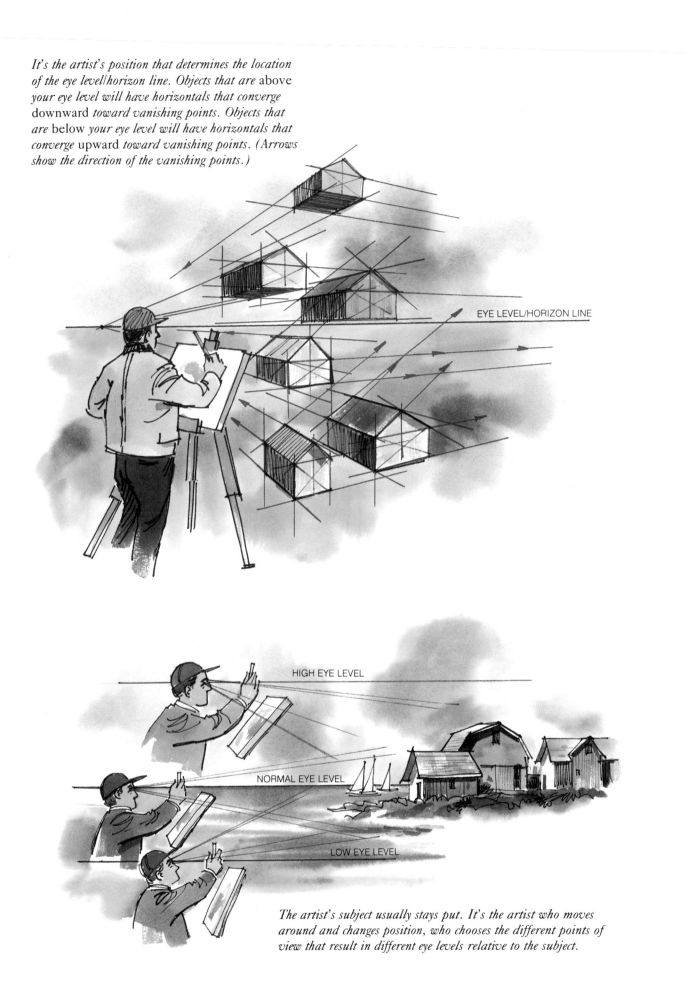

It's the artist's position that determines the location of the eye level/horizon line. Objects that are *above* your eye level will have horizontals that converge downward *toward vanishing points*. Objects that are *below* your eye level will have horizontals that converge upward *toward vanishing points*. *(Arrows show the direction of the vanishing points.)*

EYE LEVEL/HORIZON LINE

HIGH EYE LEVEL

NORMAL EYE LEVEL

LOW EYE LEVEL

The artist's subject usually stays put. It's the artist who moves around and changes position, who chooses the different points of view that result in different eye levels relative to the subject.

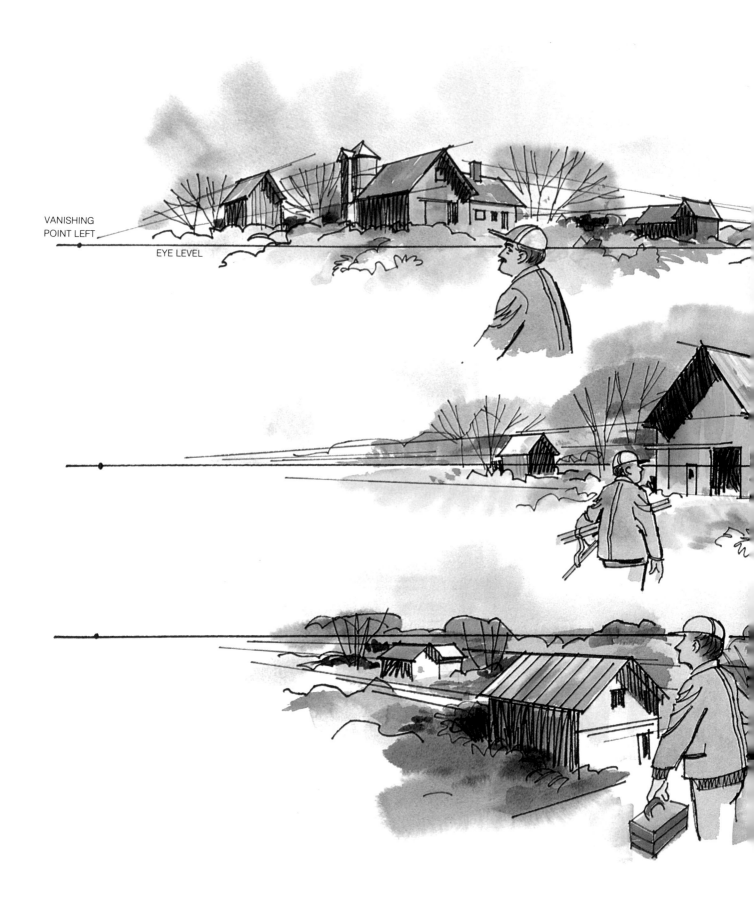

VANISHING
POINT LEFT

EYE LEVEL

Low Eye Level. *Here, the artist is positioned so far below the ground plane of the subject that the eye level is entirely below it. Horizontals angle downward as they converge toward their vanishing points.*

VANISHING
POINT RIGHT

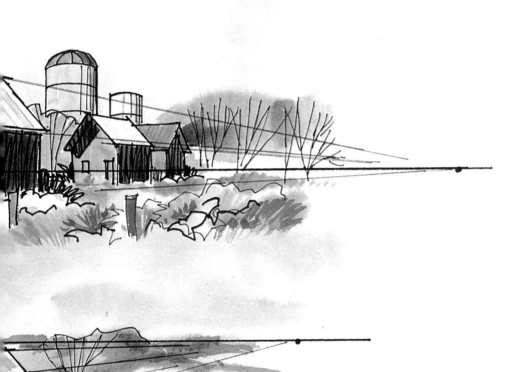

Normal Eye Level. *Now the artist is about level with the subject. Typically, the eye level/horizon line crosses the subject at some point above the ground plane but not above the subject itself. Horizontals above eye level will converge downward; those below eye level will converge upward toward their vanishing points.*

High Eye Level. *Here, the artist is elevated above the subject's ground plane; the eye level is located entirely above the subject. In this case, horizontals will angle upward as they converge to their vanishing points. Generally speaking, if your eye level is 30 feet or more above the ground plane of your subject, you'll have a high-eye-level view of houses, barns, and other structures. In the case of taller buildings that are several stories high, a portion of the building may extend above the eye level/horizon line and have horizontals that converge downward, but the painting as a whole will still be seen from an overall high-eye-level point of view.*

VANISHING POINTS

By plotting straight paths of light from the surface of an object to the eye, and continuing these lines back through the transparent surface of the picture plane, you can see the process of diminution that takes place as an object, or series of objects, recedes into space. If you actually draw these paths of light on your painting surface as a series of straight lines right through the object, you see that the lines in any set of parallel lines that go back in space move closer and closer together until they merge in a single point, where they appear to vanish. This is their *vanishing point*. Only lines that go back in space, away from the eye, end in vanishing points. Any lines parallel to the picture plane, and thus perpendicular to your main line of sight, will not go back in space and so will not come together in a vanishing point.

Any pair or group of parallel lines that have some angular relationship may require a specific vanishing point. A single drawing may need many vanishing points in order to define a number of different objects or a single object made up of a number of different angles. Most often, however, a drawing will call for only two main vanishing points. These may be located anywhere, on or off the picture format. They can be on the eye level/horizon line, in the air above it, or underground below it. They can be placed relatively close together or spread far apart. Unlike the mechanical artist who plots the vanishing points first and then draws the subject from them, the freehand artist locates the vanishing points wherever parallel lines that go back in space happen to converge. And where they happen to converge will depend on two variables: (1) the distance between station point and subject, which will determine the feeling of near or far, and (2) the location of the theoretical picture plane relative to station point and subject, which will determine the size, or format, of your painting.

In addition to these two factors, you should also consider the eventual viewing distance when plotting your vanishing points. Generally speaking, a large painting with a wide field of view will call for widely spaced vanishing points, and a smaller painting with a narrower field of view more closely spaced vanishing points. In the same size format, widely spaced vanishing points will produce wide angles and less feeling of depth, whereas more closely spaced vanishing points will produce more acute angles and a greater effect of depth.

How far apart you place your vanishing points depends on how large your format is and how far back the viewer will be able to get from the surface of the painting. How close together you can place your vanishing points is another matter. If they are too close, your image will be distorted. A good rule of thumb to follow is *Always have your vanishing points at least as far apart as twice the diagonal of your picture format* and *never closer together than 24 inches.*

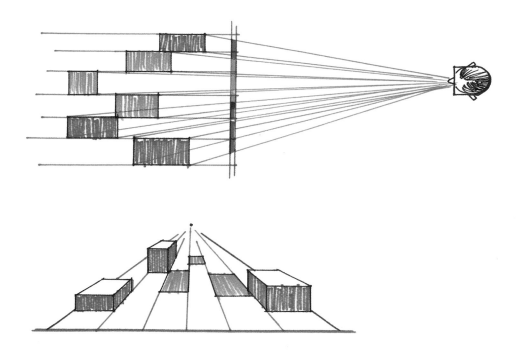

The ground-plan view top *shows the observer in relation to the subject, with lines of sight indicated by visual "tracers" drawn from the subject, through the picture plane, to the observer's eye. Below, we see the same subject from the observer's point of view. Notice how lines that are actually parallel when seen from above appear to converge in a vanishing point when seen head-on.*

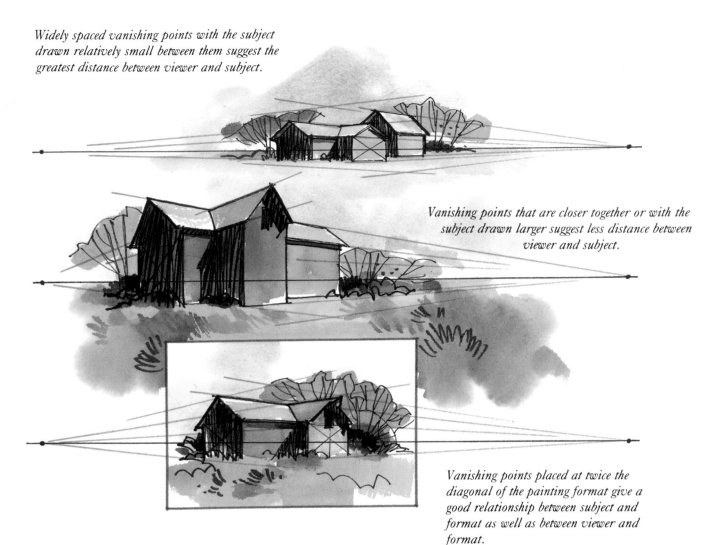

Widely spaced vanishing points with the subject drawn relatively small between them suggest the greatest distance between viewer and subject.

Vanishing points that are closer together or with the subject drawn larger suggest less distance between viewer and subject.

Vanishing points placed at twice the diagonal of the painting format give a good relationship between subject and format as well as between viewer and format.

All parallel horizontal lines vanish to the same vanishing point on the eye level/horizon line.

Buildings that are parallel to one another, even if separated by distance, use the same set of vanishing points.

The same spread between vanishing points serves for a close subject as for a distant one. It's just a matter of how much space between vanishing points the subject will occupy.

Guidelines for locating vanishing points

The following guidelines are based on a 50-degree field of view, which will result in what is considered "normal" perspective. (Note that the vanishing points in some of the illustrations in this book are closer together than these guidelines dictate in order to fit them into the format of the book so that you can see them. However, in doing a painting or any piece of art meant for exhibition, these guidelines apply.)

1. Your station point (working distance), as well as the viewing distance, should be the *same as the diagonal of your picture format*. If your painting surface measures 24 inches on the diagonal, you should be about 24 inches away from it while you work, and you can assume that the viewer will be about 24 inches away from it when it's finished.

2. Your vanishing points, in order to place you and the viewer at the correct distance from the picture surface, should be *at least as far apart as twice the diagonal of your picture format*. They can be much farther apart, but they should *never* be less. So for a 24-inch diagonal, your vanishing points should be no closer than 48 inches.

3. For very small formats, where you cannot work at a distance that equals the diagonal because if you did you would be too close to your surface, assume a *minimum* working/viewing distance of 12 inches. This will give you vanishing points that are 24 inches apart, which is as close together as vanishing points should *ever* be placed unless you're painting miniatures to be looked at under a magnifying lens.

The distance between vanishing points and their relationship to the picture format will vary according to how the subject is oriented to the picture plane. For a building (or any boxlike shape) with equal/equal emphasis on the two visible sides, the subject is more or less centered between vanishing points spaced at our "rule of thumb" distance of at least twice the diagonal of the picture format.

NISHING POINT LEFT VANISHING POINT RIGHT .

With an unequal, one-third and two-thirds emphasis on the two visible sides, the relationship of vanishing points to picture format changes, and the subject shifts to one side or the other. The spread between vanishing points has increased to at least three times the diagonal of the picture format.

When the subject is rotated again to present maximum inequality between the two visible sides, the relationship of vanishing points to format changes still more dramatically, and the spread between them expands to at least four times the diagonal of the picture format.

THREE-DIMENSIONAL FORMS

To better understand how to apply perspective to a three-dimensional object in space, you can begin by drawing a cube—the basic three-dimensional form—from various angles. The cube as a form is evident in most manmade objects, including houses, barns, skyscrapers, interiors and their furnishings, automobiles, even boats. Once you know how to draw a cube from different angles, you will find it much easier to draw any cubelike object. And you'll be able to draw it from any position—from above, from the side, straight on, or even from inside it.

When you draw the cube, you'll be using the three perspective systems you'll need in order to draw forms in space. You'll see how the cube, or any three-dimensional object, casts shadows and how shadow projection according to perspective principles enables you to enhance the reality of any object you draw. Knowledge of light-and-shadow perspective is one of the most flexible and creative tools we have. With it, you can decide where shadows will fall, which face of a building to put in sunlight and which in shade, or whether the shadow patterns will suggest early morning, high noon, or late afternoon. You can shroud a figure in mystery or add atmosphere to an interior scene. With the creative use of light and shadow, not only can you more fully explore the forms and volumes of a subject, but you can use shadow to enhance your compositional values as well.

PERSPECTIVE SYSTEMS

A cube can technically be described as a three-dimensional rectangular prism, which means that it has six flat surfaces (or faces) in three sets of matching pairs, each surface at a right angle to the surfaces adjacent to it. It has a total of twelve edges, in three parallel sets of four, each set at a right angle to the edges adjacent to it. In other words, it's a box.

It's the orientation of the sets of edges to your main line of sight—and thus to the picture plane, which is always perpendicular to the main line of sight—that determines how many vanishing points you'll need to draw the cube. The number of vanishing points—one, two, or three—defines the perspective system you'll use.

One-point perspective

One-point perspective occurs when two faces of the cube and two sets of edges are parallel to the picture plane. In this position, *one* set of edges goes back to converge in *one* vanishing point.

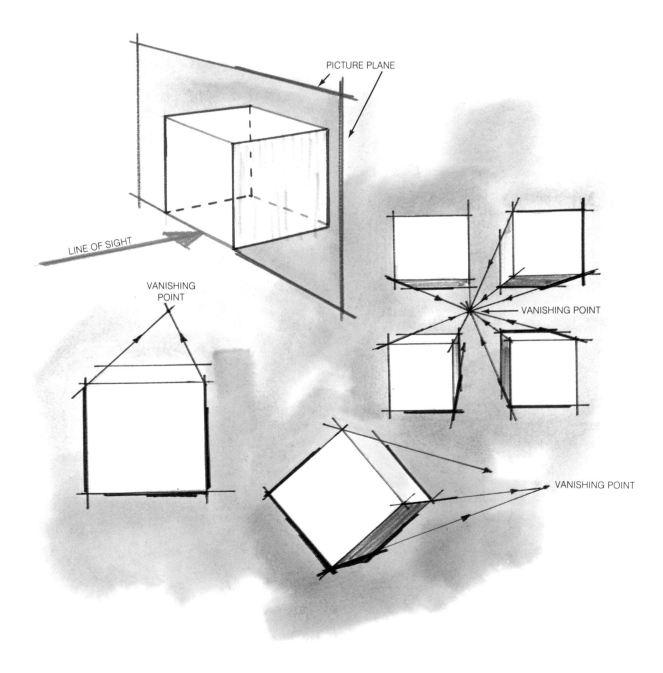

Two-point perspective

Two-point perspective occurs when you rotate the cube so that *none* of the faces are parallel to the picture plane, but *one* set of edges still is. Now *two* sets of edges go back in space to converge in *two* vanishing points.

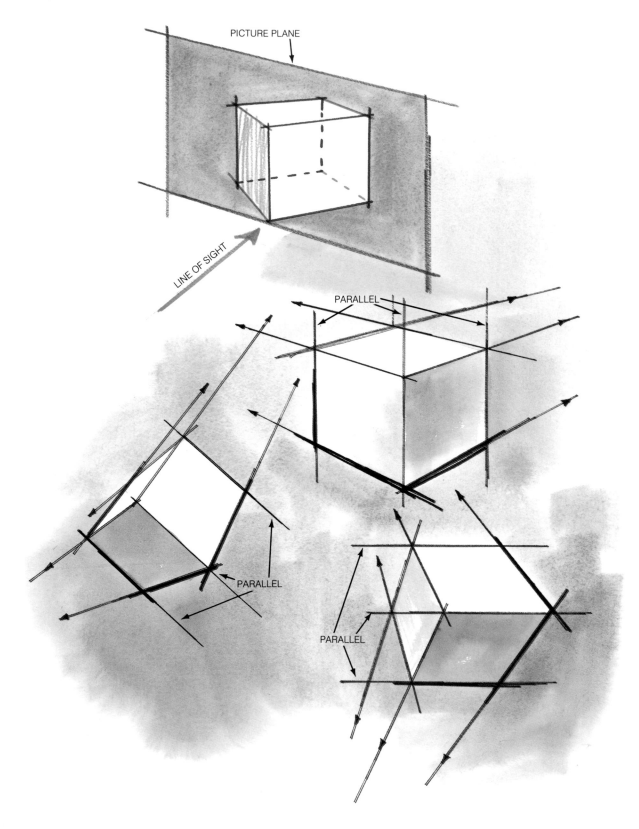

Three-point perspective

Three-point perspective occurs when you rotate the cube once again, this time positioning it so that none of the faces and none of the edges is parallel to the picture plane. Now all *three* sets of edges go back in space to converge in *three* vanishing points.

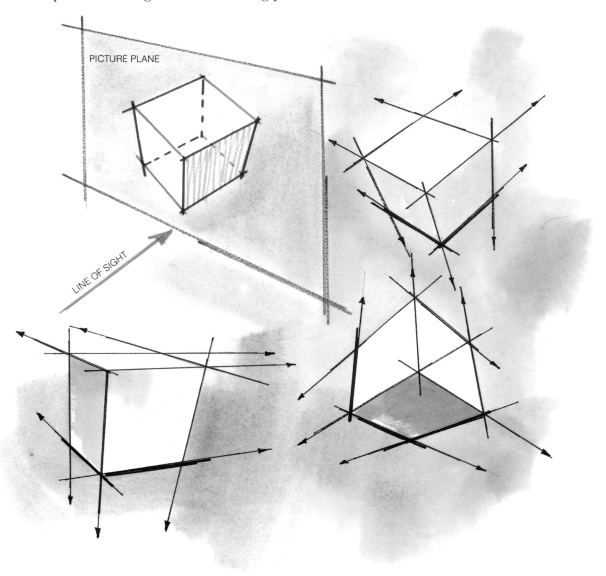

PICTURE PLANE

LINE OF SIGHT

If you draw your cube level, that is, with its edges horizontal and vertical, as if it were a box sitting on a table, your vanishing point(s) in both the one-point and two-point systems will be located on the eye level/horizon line. In the three-point system, two of the vanishing points will be on the eye level/horizon line and one will not be. If you tilt the cube off level as you rotate it, your vanishing points for horizontal lines will be located on an auxiliary eye level/horizon line that will tilt left or right as the cube is tilted. The vertical edges, which tilt toward or away from the

observer, will converge to a vanishing point located on a vertical line, called a *vertical vanishing trace*, that will change its angle as the vertical edges change theirs.

Whether level or tiled, it's the fact that the cube has two sets, one set, or no sets of edges parallel to the picture plane, leaving *one* set, *two* sets, or *three* sets, respectively, to converge in vanishing points, that determines the perspective system. The terms *one-point*, *two-point*, and *three-point* perspective apply only to the system used to draw individual objects, not to the entire painting.

SHADOW PROJECTION

Although you can fully define a form through the use of line alone, there are times when it could be made more interesting and more realistic with the addition of light and shadow.

Because all rays of light, whether from the sun or from an artificial source, travel in straight lines, the shadows caused when anything blocks their path follow the same rules of perspective as any other linear phenomenon: shadows that recede into the picture depth are defined by parallel lines that converge in a vanishing point, and the light rays that cast the shadows will converge to a separate vanishing point; shadows that are cast parallel to the picture plane are defined by lines that do not converge, and light rays parallel to the picture plane do not converge. It's the angle of the rays of light, from whatever source, relative to our station point and our picture plane, that determines the direction and perspective effect that the shadows will have.

When changing or inventing light-and-shadow effects on buildings, or any structure, you can choose from several possibilities:

Both faces in sunlight. Here, the shadow vanishing point on the eye level/horizon line is located between the two main building vanishing points, and the sun is behind the observer.

Both faces in shadow. The shadow vanishing point is still located between the two building vanishing points, but the sun is in front of the observer.

One face in sunlight and the other in shadow. Now the shadow vanishing point is outside the two building vanishing points, and the sun is either in front of or behind the observer; or to the side, parallel to the picture plane.

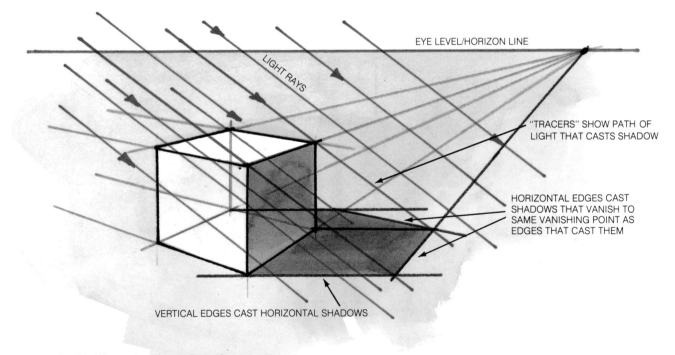

EYE LEVEL/HORIZON LINE

LIGHT RAYS

"TRACERS" SHOW PATH OF LIGHT THAT CASTS SHADOW

HORIZONTAL EDGES CAST SHADOWS THAT VANISH TO SAME VANISHING POINT AS EDGES THAT CAST THEM

VERTICAL EDGES CAST HORIZONTAL SHADOWS

In this illustration, sunlight strikes a cube resting on a level surface. The light rays come from the side and are parallel to the picture plane.

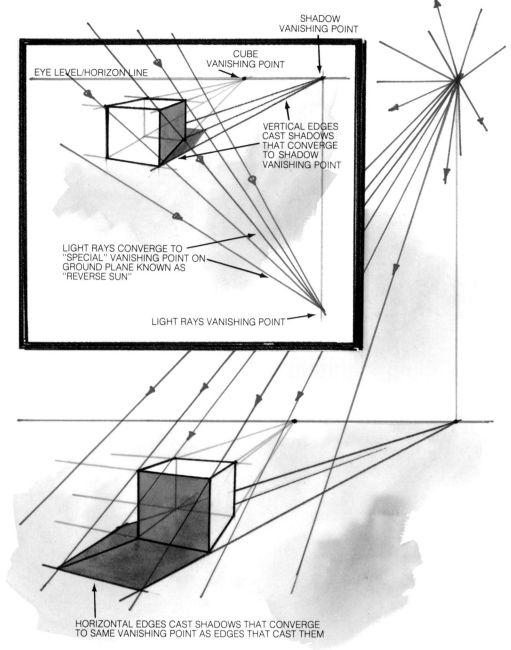

Here, sunlight strikes the cube from over the observer's shoulder or behind the observer (in front of the subject). The light rays are no longer parallel to the picture plane.

SHADOW
VANISHING POINT

CUBE
VANISHING POINT

EYE LEVEL/HORIZON LINE

VERTICAL EDGES
CAST SHADOWS
THAT CONVERGE
TO SHADOW
VANISHING POINT

LIGHT RAYS CONVERGE TO
"SPECIAL" VANISHING POINT ON
GROUND PLANE KNOWN AS
"REVERSE SUN"

LIGHT RAYS VANISHING POINT

This time the cube is lit by sunlight coming from in front of the observer (behind the subject).

HORIZONTAL EDGES CAST SHADOWS THAT CONVERGE
TO SAME VANISHING POINT AS EDGES THAT CAST THEM

Whichever condition you're working with, you can modify the relationship between the height of the sun and the location of the shadow vanishing point in order to control the cast shadows. You'll need an additional shadow vanishing point—positioned relative to the height of the sun—for shadows that are cast on a sunlit wall. This vanishing point is located on a vertical line drawn through the vanishing points for the wall. By using these reference points, you'll be able to convincingly draw all the shadows within the picture. Remember, you can choose or change these points of reference to create whatever shadow effects you want, as long as your shadows are consistent within a single overall point of view.

An alternate way to find your reference points is to draw the desired shape for a major shadow and then extend the shadow edges in order to locate them. The other shadows can then be drawn in the same perspective.

It's not always necessary for you to work out your shadow reference points exactly, but you do need to understand their interrelationships and have an approximate idea of their positions in order to invent or rearrange light and shadow in a convincing manner.

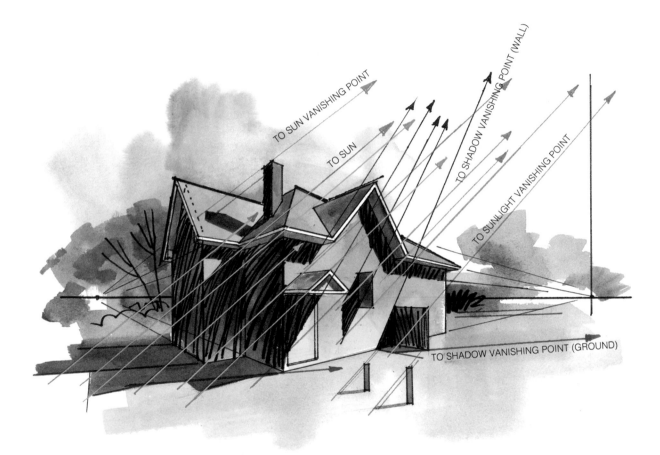

Sun in Front of Observer. *The easiest procedure is for you to visualize any interesting shadow angle projected on the lit face of your subject and use this to project the position of the sun and the way all the other shadows will fall. Here you see the shadow cast by a small projecting signboard. The line of this shadow is extended up until it crosses a vertical line drawn through the building vanishing point. Then, the position of the shadow vanishing point on the eye level/horizon line is located or estimated. Our next concern is how high the sun has to be above this point to give an interesting angle. All other shadows are developed by drawing a reference line perpendicular to the sunlit face, drawing the shadow from the shadow vanishing point (wall) through the base of the perpendicular line, and cutting its length off by running a "tracer" from the sun's vanishing point past the end of the perpendicular line to the cast shadow.*

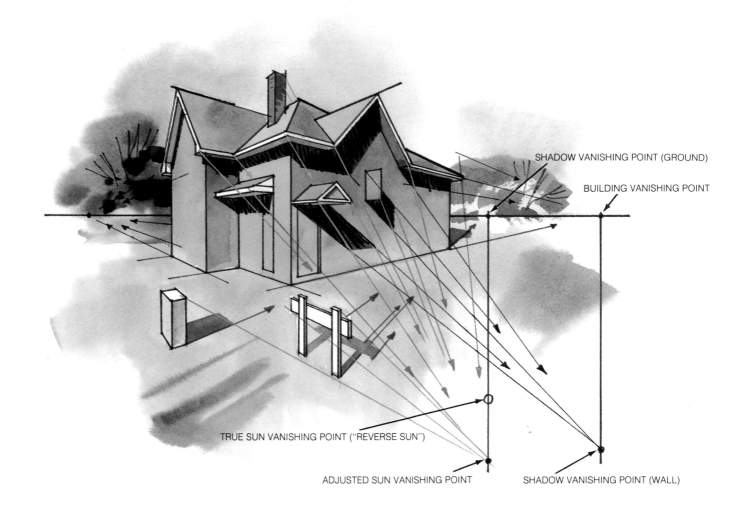

SHADOW VANISHING POINT (GROUND)

BUILDING VANISHING POINT

TRUE SUN VANISHING POINT ("REVERSE SUN")

ADJUSTED SUN VANISHING POINT

SHADOW VANISHING POINT (WALL)

Sun Behind Observer. *When the sun is behind the observer, the light rays vanish to a point* below *the shadow vanishing point (ground). The distance this point lies below eye level is the same distance that the sun would be above eye level if the observer were to turn around and look in the opposite direction. This point is thought of as a "reverse sun," since the light rays vanish to it.*

For projecting shadows, draw reference lines perpendicular to the sunlit face of your subject, and draw the cast shadows from the base of those reference lines to the shadow vanishing point (wall).

With both faces in sunlight, the shadow vanishing point (wall) will be located below the building vanishing point for the wall receiving the cast shadow. When one building face is in shadow and one in sunlight, it's possible for the shadow vanishing point (wall) to be located above or below the appropriate building vanishing point, depending on which way the sunlight is intended to fall.

In this drawing, the sun vanishing point has been shifted to shorten the length of shadows cast on the wall.

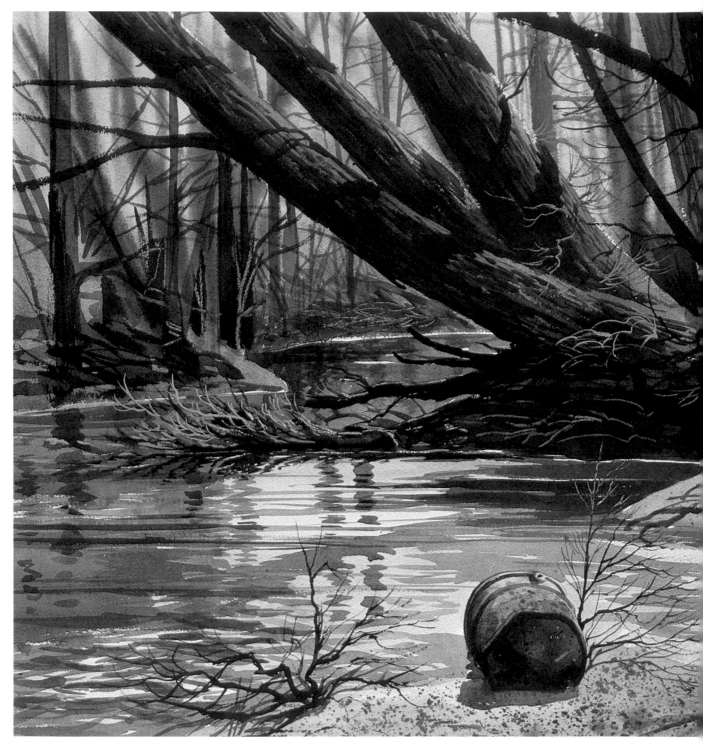

RIVER WILLOWS, *watercolor*,
20" x 28" (51 x 71 cm).

Part Two
PUTTING PERSPECTIVE TO WORK

LANDSCAPES

The word *landscape* is linked so closely with the word *painting* that often one thinks of the two as if they were synonymous. Indeed, landscape of one kind or another does make up the greater part of an artist's subject matter, encompassing as it does the entire found world, from rolling hills and fields to mountains, city street scenes, ocean views, and even interiors in which a view to the outdoors is a prominent feature. Everything out there is landscape, and because it's such a vast subject and one that the artist goes out to meet instead of arranging in the studio, it presents unique opportunities for interaction between artist and subject, for visual commentary and interpretation.

In cases where the landscape combines natural forms with manmade ones, a visual tension is set up between complementary opposites—soft with hard, curved with straight, random with regular, small with large—that provides unlimited possibilities for exploring not only the compositional aspects of a scene but also the emotional ones. Think of the impact of a lone building in a deserted landscape, an abandoned vehicle or derelict barn in an overgrown field, or a lighthouse tower against a great expanse of sky. Each of these subjects can contain a world of thought, feeling, and comment in addition to their purely visual representation.

Landscape painting, when handled skillfully, can actually transform the way we see reality.

LOW EYE LEVEL

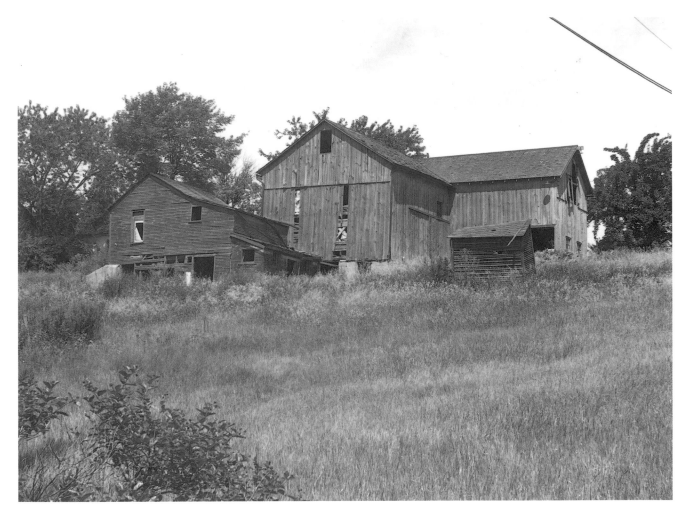

Barns and outbuildings such as this are a common sight in the Midwest. This one, in Michigan, offers everything a painter could want in a subject. Besides its evocative appeal, this particular grouping provides a dynamic interplay of lines, shapes, sizes, heights, areas of light and shade, and directions of thrust, all contained in a satisfying massed overall shape well placed in its surroundings. It also provides a good example of a typical perspective situation, a subject situated above the artist's eye level, resulting in a low-eye-level—or uphill—view.

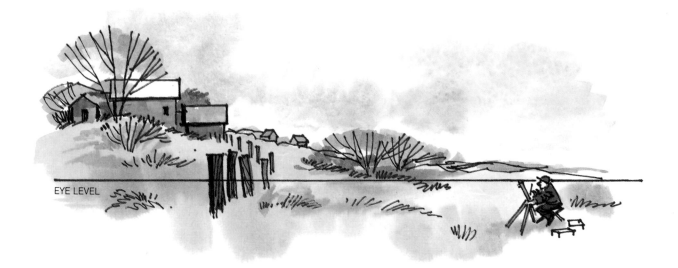

EYE LEVEL

Here you can see what is meant by a low-eye-level view. Any subject that you have to look up at as you work, which is situated on ground higher than you are, results in your eye level being low in relation to it. Here, the subject is on a rise of ground that's a good deal higher than the artist's eye level, which in this case is below the level of the buildings by a distance roughly equal to the height of the tallest structure.

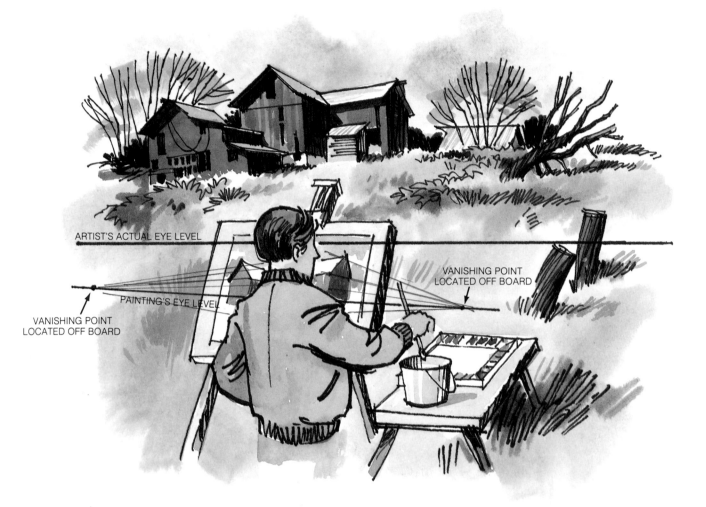

ARTIST'S ACTUAL EYE LEVEL

VANISHING POINT
LOCATED OFF BOARD

PAINTING'S EYE LEVEL

VANISHING POINT
LOCATED OFF BOARD

Once you locate your actual eye level, the next step is to transfer it
to your working surface in the form of the eye level/horizon line. To
help establish your actual eye level, hold something up in front of
you between your eye and the subject. A straightedge, painter's
mahlstick, carpenter's level, even your thumb, or a stick picked up
off the ground will do. Extend it at arm's length, parallel to the
ground plane and level with your eye; notice where it "hits" your
subject. This is your actual eye level. When you rough in the
composition, merely transfer the relationship you see between this
eye level and the subject to your working surface when you draw in
the eye level/horizon line. Once the eye level/horizon line is
established, the key vertical and horizontal lines of the buildings are
used to locate the vanishing points, and all the other lines of the
subject can be plotted in relation to these initial guidelines.

Do a series of thumbnail sketches before starting to paint. These will familiarize you with the subject and help you choose the most effective view. Sketches let you explore various design opportunities offered by your subject and experiment with different approaches without wasting a lot of time. Once you've done enough sketching to fix on the size and position of your subject, you're ready to start painting.

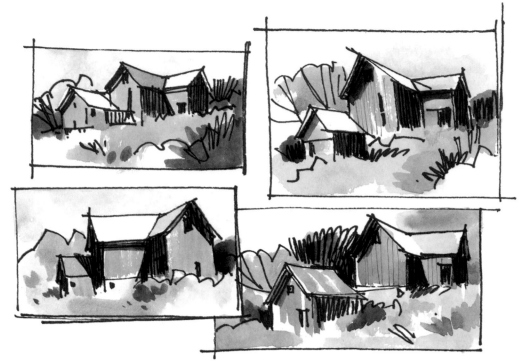

← VANISHING POINT LEFT

CONVERGING PARALLELS

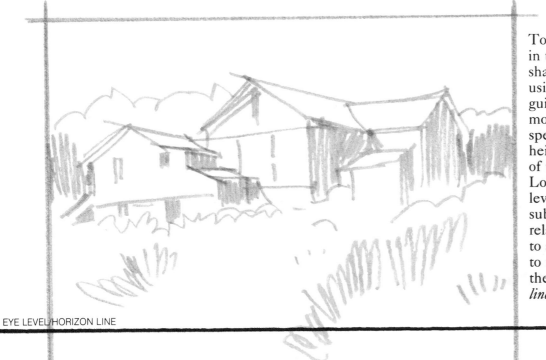

To begin, lightly rough in the approximate shapes of the buildings, using your sketches as a guide to placing them most effectively. Pay special attention to the height-to-width ratios of the overall mass. Locate your actual eye level as it bisects the subject and transfer the relationship of eye level to subject that you see to the picture format as the *eye level / horizon line*.

EYE LEVEL/HORIZON LINE

The next step is to plot the *vanishing points*. Establish a reference point within the subject—in this case, the center corner of the barn—and use visual judgment, along with a straightedge if necessary, to identify the points where the vanishing parallels would intersect the eye level/horizon line. The vanishing points in this case are off the pages of the book. But if you were to use the overall width of the buildings as a unit of measure, with the center corner of the barn as a starting point, the left-hand vanishing point would be five units away and the right-hand vanishing point would be two units away.

CONVERGING PARALLELS

VANISHING POINT RIGHT ⟶

EYE LEVEL/HORIZON LINE

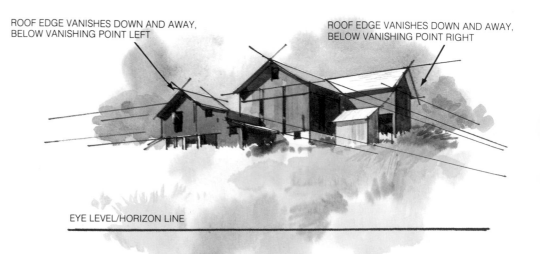

ROOF EDGE VANISHES DOWN AND AWAY, BELOW VANISHING POINT LEFT

ROOF EDGE VANISHES DOWN AND AWAY, BELOW VANISHING POINT RIGHT

EYE LEVEL/HORIZON LINE

With the eye level/horizon line and the vanishing points established, proceed to refine the rest of the composition. In drawing buildings, pay careful attention to which way the various lines slope so that you draw them going toward the correct vanishing point. Sometimes it's hard to tell which lines should go left and which should go right. You have to use your best judgment. In this subject, the lines are clear; even the lines of the foundation have an obvious angle toward their vanishing points, which adds to the strong impression that the subject is situated well above the viewer's eye level.

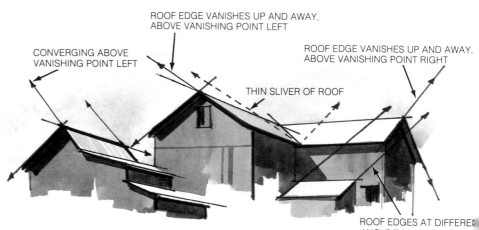

ROOF EDGE VANISHES UP AND AWAY, ABOVE VANISHING POINT LEFT

CONVERGING ABOVE VANISHING POINT LEFT

THIN SLIVER OF ROOF

ROOF EDGE VANISHES UP AND AWAY, ABOVE VANISHING POINT RIGHT

ROOF EDGES AT DIFFEREI ANGLE THAN BARN ROOF

For perspective in buildings to be convincing, it is vital that the roof "sit" on a building properly; an inaccurately rendered roof can throw your whole composition off kilter. From this low eye level, the visible roof surfaces are quite narrow, just thin slivers. Be precise in the way that roof surfaces fit together, and note that whereas the parallel horizontal lines will converge to a vanishing point on the eye level/horizon line, the sloping roof edges of the gable ends also obey the laws of perspective and converge toward a different vanishing point, which will be found above (or below) the building vanishing point.

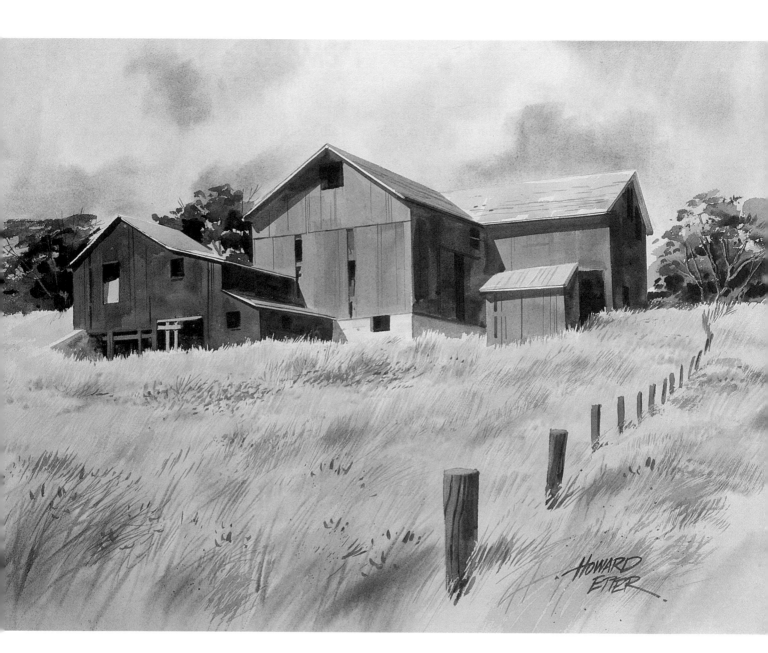

BARN ON A HILL, *watercolor on canvas, 20" × 26" (51 × 66 cm)*.
In the finished painting, the vertical lines have been tilted slightly to the
left to give a feeling of movement to the composition, and the height of
the barn's main roof peak has been exaggerated a bit to "lift" the
building mass as it comes forward in space. Detail work was kept out of
the grassy foreground so that it wouldn't compete with the building for
attention. The line of fence posts was included both to make up for this
lack of definition and to show the depth of the foreground space.
Liberties were taken with the position of the sun so that some of the
surfaces could be rendered in full shadow to give a more dramatic
impression of three-dimensional volume.

HIGH EYE LEVEL

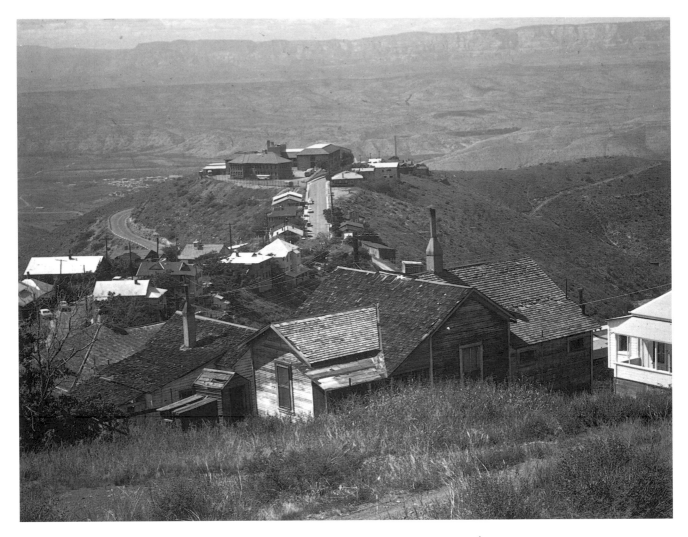

The deserted mining town of Jerome, Arizona, offers the painter a wealth of choices of uphill or downhill views with a variety of different groupings of small and medium-size buildings. Much of the town was built on a steep hillside, and some of the older houses have had the clay subsoil slip out from beneath them, leaving them tottering on the brink of collapse. This combination of dramatic angles, distant vistas, and ghost-town structures makes Jerome a bonanza for artists. A high-eye-level, or downhill, view was chosen for this demonstration. The viewer looks across from one hillside to another, smaller hilltop, with houses and a school building at its crest. Beyond this, many miles distant, is another ridge of relatively barren rocky slopes.

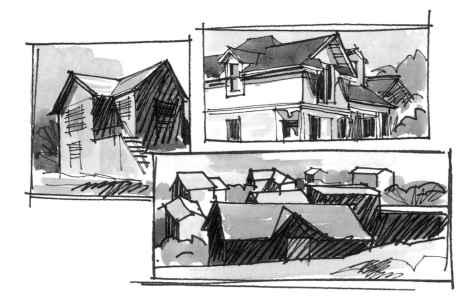

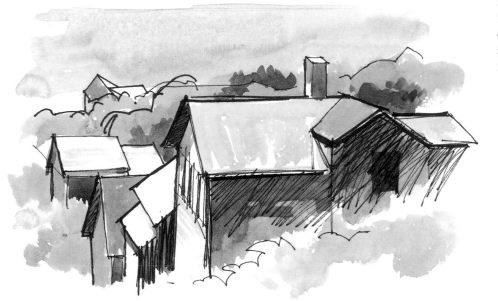

In locations like this, which offer a variety of interesting views and approaches, examine a number of different possibilities before deciding on your final viewpoint. Rough sketches such as these allow you to study various angles and/or subjects very quickly. They also help focus your attention on what you're looking at and prepare you mentally for the more complete drawing and painting process. Other facets explored here are the variations in light and shadow as light moves from the sharp contrast of the foreground to the softer contrasts of the more distant planes.

The most distant building group seems to be flattened in depth because it's so far away from our station point and its vanishing-point spread is so wide. You can draw some of these buildings in one-point perspective, paying careful attention to their stacked effect as they recede up the hill and away from the foreground. The street that leads uphill must have a higher vanishing point, one above the eye level/horizon line, to indicate that it's not level but angles upward.

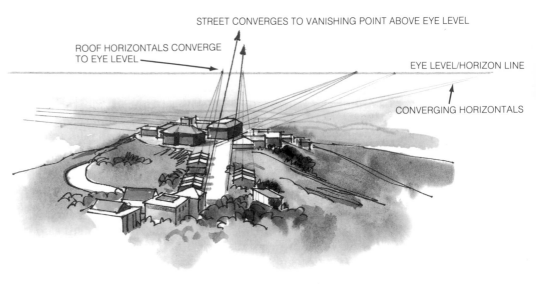

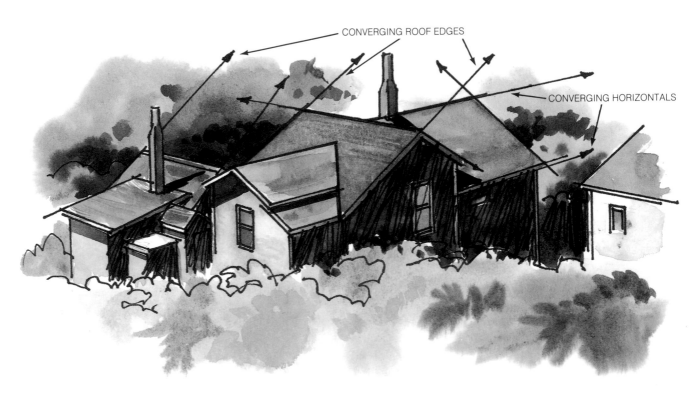

The vanishing points for the central building are spaced a distance equal to about two-and-a-half times the diagonal of the picture format. The other, more distant buildings should have a similar vanishing-point spread, but the location of their vanishing points will vary according to the angle of the buildings relative to the picture plane. The angles of the roofs are especially important to the perspective of this subject because the view is from above. Since these buildings are more or less sound, their lines will be straight enough to follow the basic rules of linear perspective.

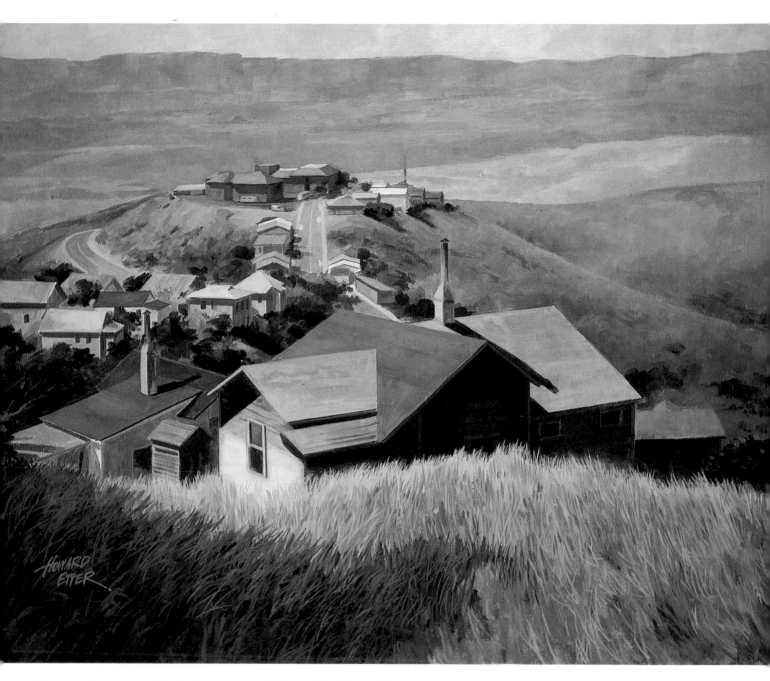

VIEW OF JEROME, *oil/alkyd on canvas, 24" × 30" (61 × 76 cm)*.
In the finished painting, atmospheric perspective has been added to
linear perspective to show the subject's extreme depth. The distant
hills are many miles away, with no linear features to provide visual
cues. Instead, a strong contrast of light and shadow was used in the
foreground, gradually softening as the subject recedes deeper and
deeper into the space of the picture.

MEDIUM EYE LEVEL

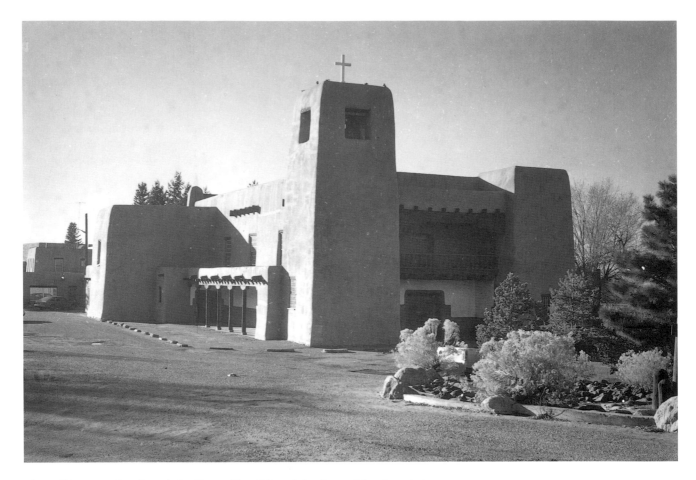

A well-known landmark in Santa Fe, New Mexico, this church is located near the oldest church in the United States. With less historical significance than the older church, it is nevertheless interesting to the artist. Since it stands slightly apart from nearby structures, it can be viewed from a number of vantage points and different angles of light. This photograph shows the church lit by dramatic afternoon sunlight. In the morning, the façade of the building is bathed in light, which reveals other aspects of the forms of the structure. The final painting uses morning light, even though the source shows afternoon light. The point of view here is straight ahead, at medium eye level.

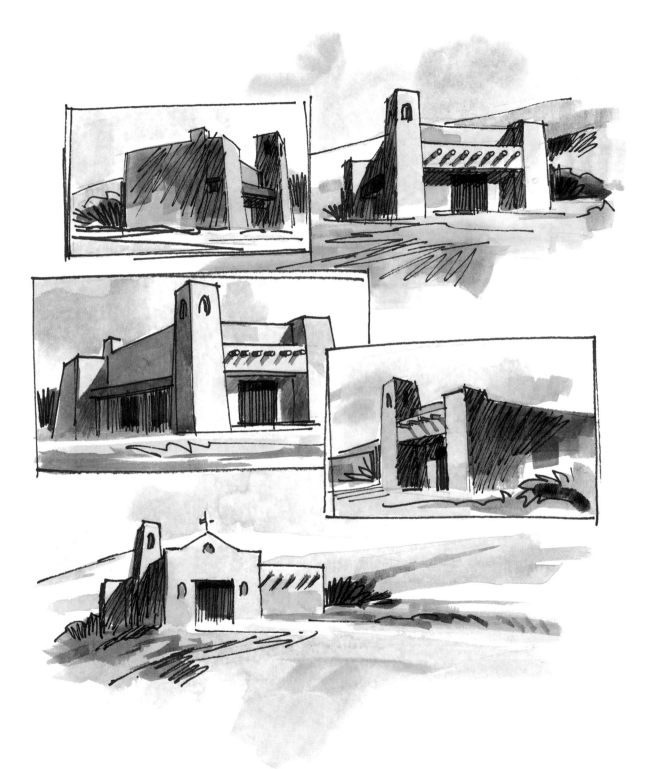

Light and shadow always play an important role in creating visual interest in the simple forms of an adobe building. Here, sketchbook studies help analyze the composition and determine the most effective point of view. They also show changes in light and shadow that will help emphasize the volume of the forms and how the masses of the building fit together. You can use sketches of different structures of the same type, since all have a common visual vocabulary you can draw on for your painting.

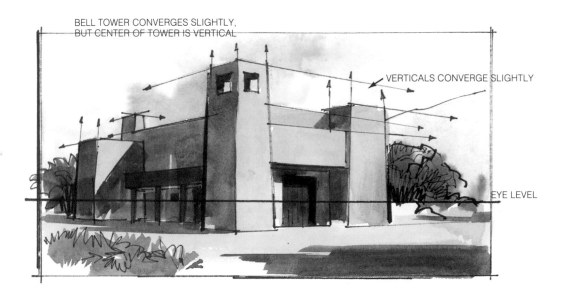

The perspective of this subject is fairly straightforward, but careful study is needed for the vertical edges. Adobe-style construction is often slightly tapered at the corners, and its verticals are not really true but move closer together as they rise above the ground. This converging, although not great, must be shown, but it must be handled subtly to avoid the appearance of a perspective effect. Note that the building mass itself does not tilt in; only the corner towers slope inward as they rise.

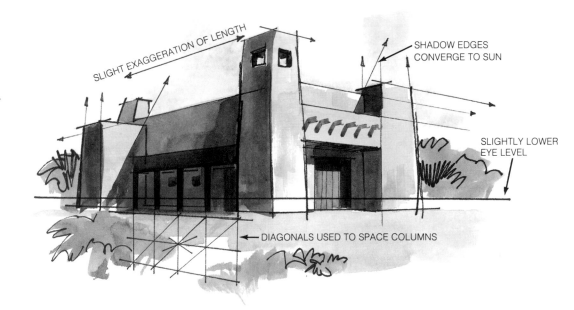

Here, the composition has been adjusted somewhat: the perspective angle has been exaggerated for dramatic effect, and the eye level/ horizon line has been lowered to emphasize the upward thrust of the bell tower. The whole side of the building has been lengthened to avoid too squarish a massing of volumes.

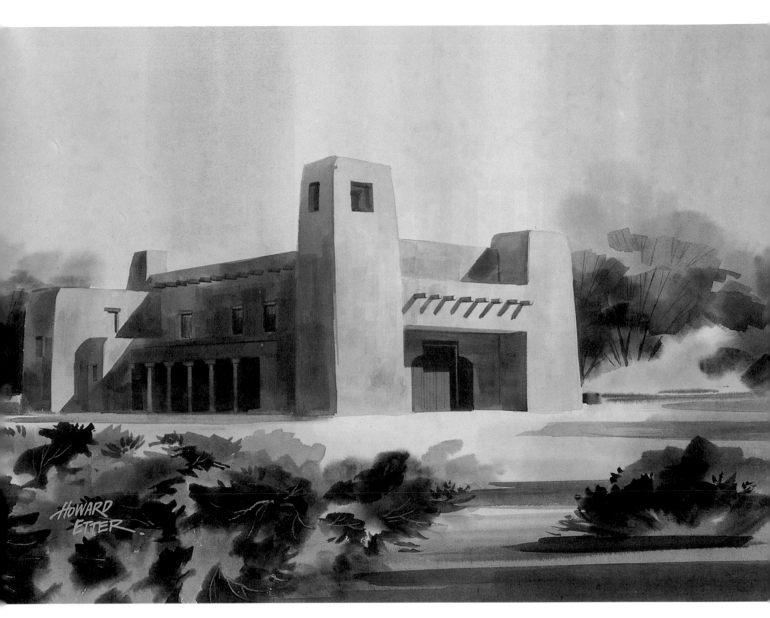

SANTA FE CHURCH, *watercolor, 20" × 26" (51 × 66 cm).*
In the finished painting, you can see that the angle of sunlight has
been changed to light the front of the church, leaving the side in
shadow. This morning lighting effect strengthens the feeling of
volume. The shadow side of the building and the dark shadows on
the ground act as a foil for the bushes in the foreground.

MULTIPLE VANISHING POINTS

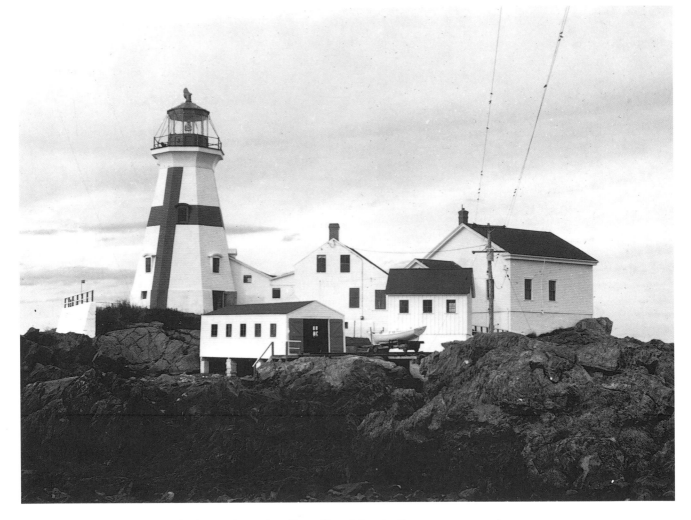

This lighthouse complex is located on the Canadian island of Campobello. Frequent visits have yielded a number of sketches and drawings of the subject, as well as photographic reference material. When doing rough sketches and taking photographs of the same subject, you'll find that it's often the sketches that provide the most accurate impression of the subject as a whole. Photographs fill in the details of texture and light-and-shadow patterns that may be useful for the actual painting. This subject is made up of a number of different masses—each requiring vanishing points—that are located just above the viewer's eye level, almost "sitting" on the eye level/horizon line, in a moderately low-eye-level view.

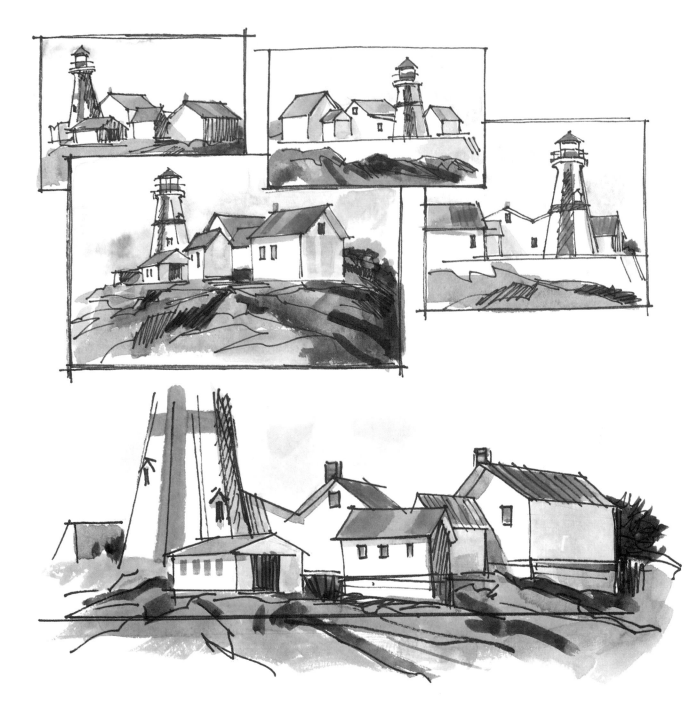

With so many components, this subject is worth examining from different angles and eye levels in a number of quick studies. If possible, walk completely around the buildings, placing yourself at different heights in relation to them, sketching as you go. This provides an opportunity to understand the way the buildings are placed and the angular relationships between them so that you'll be able to approach the perspective problems with confidence.

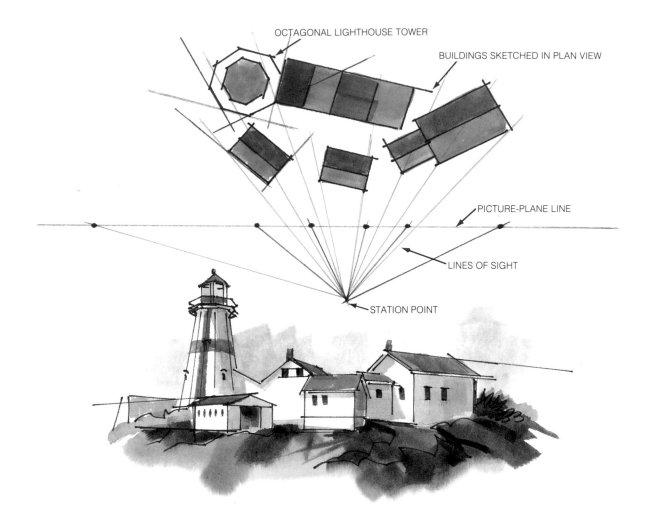

OCTAGONAL LIGHTHOUSE TOWER

BUILDINGS SKETCHED IN PLAN VIEW

PICTURE-PLANE LINE

LINES OF SIGHT

STATION POINT

When you're drawing any group of buildings, especially when they are situated at odd angles to one another, it's helpful to make a rough *ground-plan sketch*. To do this, (1) block in a bird's-eye view of the buildings, (2) indicate a station point and a picture plane, and (3) draw the lines from the station point to the picture plane, parallel to the walls of the buildings in the plan. The purpose is to help you estimate where vanishing points for the various buildings will fall. You can locate them more exactly later from the subject itself.

Three separate sets of vanishing points are required for this subject. The octagonal lighthouse tower calls for two sets of vanishing points, and the remaining building units will use the third set of vanishing points. The tower vanishing points will also serve for the faces of some of the smaller buildings, which are parallel to the tower's. There's a relatively slow convergence of the horizontal building edges toward their respective vanishing points.

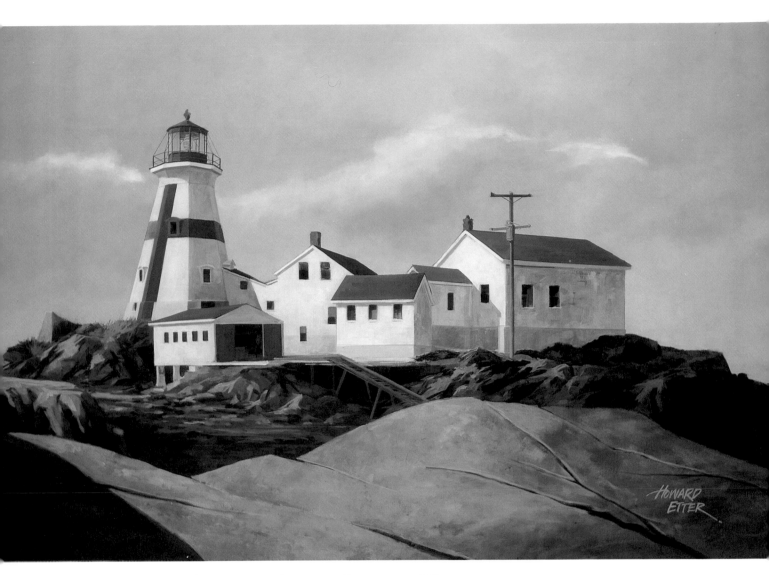

EAST QUODDY LIGHT, CAMPOBELLO ISLAND, *oil on canvas, 24" × 36" (61 × 91.5 cm)*.

The finished painting shows a slight alteration of the angle of view so there's less confusion in the overlapping buildings and better definition in the roof planes of the center building. The vanishing points are fairly wide apart, in keeping with the large format and the intended impression of a moderately distant station point. Light and shadow are used to emphasize volumes.

COMBINING ELEMENTS

These photographs show a number of different elements found at the site of an abandoned railway station in Leadville, Colorado. The buildings and train cars themselves would make interesting studies, but in this demonstration they're combined in an entirely new composition. When you are combining or rearranging separate elements, redraw the perspective of each one so that it fits into the unified point of view of the new composition.

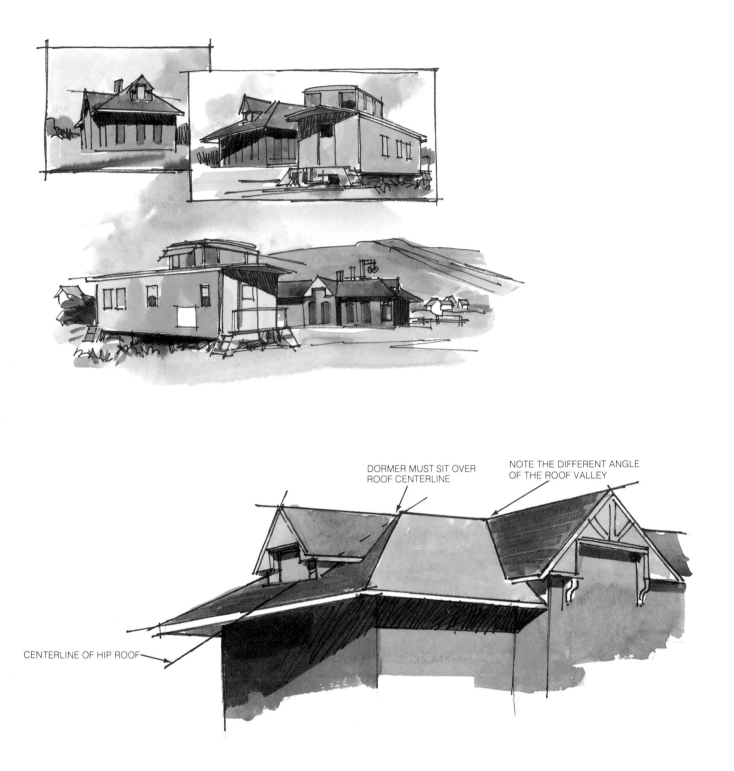

DORMER MUST SIT OVER
ROOF CENTERLINE

NOTE THE DIFFERENT ANGLE
OF THE ROOF VALLEY

CENTERLINE OF HIP ROOF

When you're trying to work a number of different objects into a coherent whole rather than draw what you see in front of you, make preparatory sketches, in which you can arrange and rearrange your material, trying out different viewpoints and relationships. Experiment with your compositon until you get something you like. Note, too, the light-and-shadow effects; try to come up with a play of light and shadow that will create interest in the final painting.

Since the caboose is much closer than the station in this composition, it requires more study with regard to details and structure. The left-hand vanishing point is quite distant, which gives a "fast" perspective effect to the long side of the car. The vanishing points for the caboose are spaced approximately the same distance apart as those for the station, but they don't coincide.

Because the station is more distant, it has a flatter perspective look, even though its vanishing points are the same distance apart as those for the caboose. The tricky parts of the station are the small dormer and where the sloping planes of the roof come together. The diagram below shows the relationship between the two sets of vanishing points and illustrates how to use a "special" vanishing point to keep the heights more or less in scale.

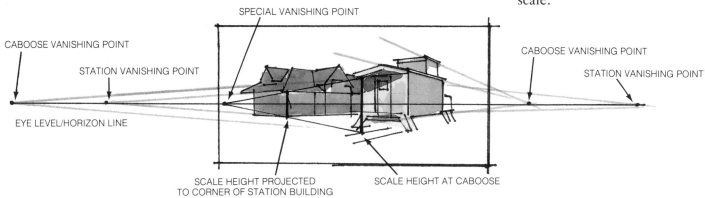

SPECIAL VANISHING POINT

CABOOSE VANISHING POINT

STATION VANISHING POINT

CABOOSE VANISHING POINT

STATION VANISHING POINT

EYE LEVEL/HORIZON LINE

SCALE HEIGHT PROJECTED TO CORNER OF STATION BUILDING

SCALE HEIGHT AT CABOOSE

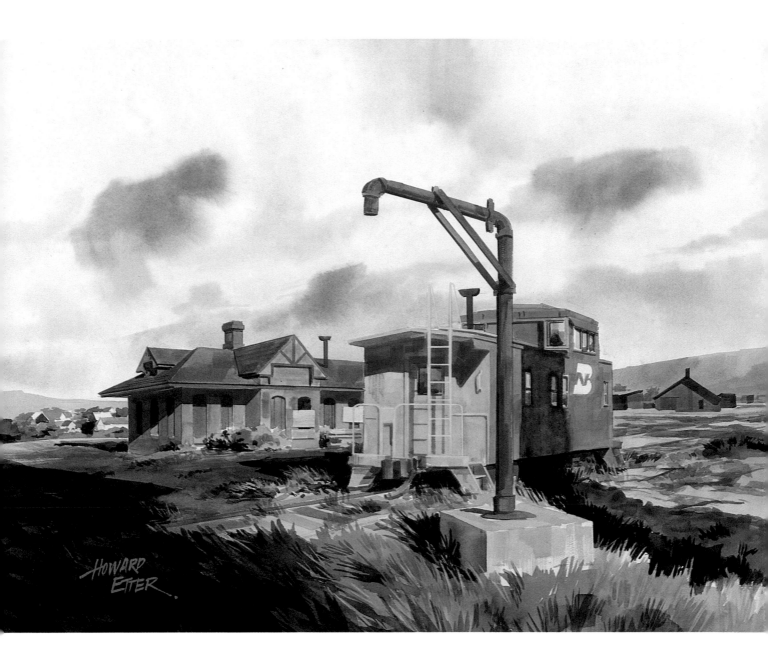

LEADVILLE STATION, *watercolor, 20″ × 28″ (51 × 71 cm).*
You can see the liberties taken with the original material: the
opposite end of the caboose was used, the station building was
reversed to show its most interesting end, and the large dormer was
moved to the left to give more rhythm to the roofline. The shapes
and details were taken from the photographs, but they have been
shifted and modified to such an extent that an entirely new reality
has been created.

INCLINED PLANES

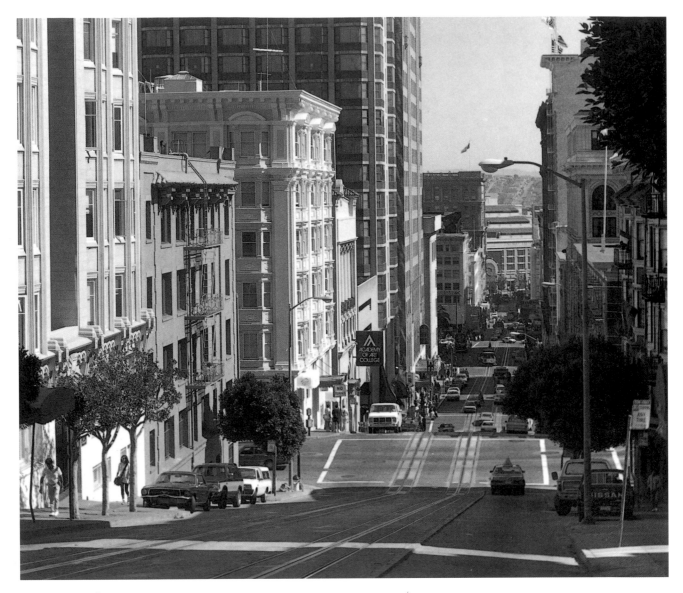

A view down Powell Street in San Francisco is a perfect example of inclined planes (planes tilted off-level), here combined with buildings to show the contrast with true vertical and horizontal lines. A steep street in a city famous for its steep streets, Powell Street also contains a variety of old and modern building styles that provides a rich tapestry of light-and-shadow pattern. As if all this weren't enough, Powell Street has one of San Francisco's famed cable-car lines for added interest. The street changes its angle from block to block as it goes downhill. It has level cross streets, which provide an ever-changing juxtaposition of planes. *Photograph courtesy Elan Santiago*

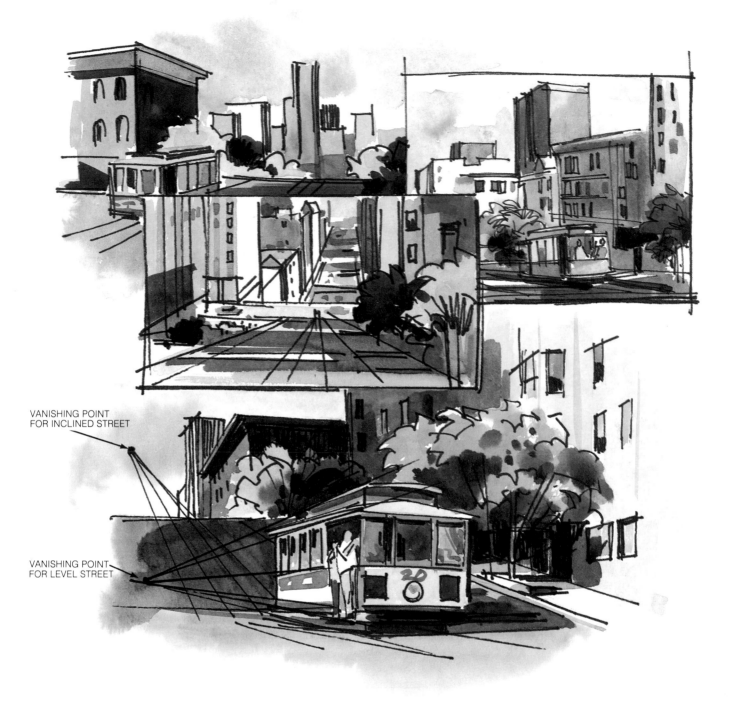

VANISHING POINT
FOR INCLINED STREET

VANISHING POINT
FOR LEVEL STREET

These sketchbook studies allow opportunity not only to explore composition but to simplify and understand a fairly complex subject. Changes can be made in the cast shadows, and the size and placement of the cable car can be roughed in. The tall buildings make the street seem quite narrow; these sketches explore the possibility of widening it. Although the main interest here is a downhill view, a look in the opposite direction could be equally interesting. The uphill view would require special treatment because of the inclined surface of the street. The vanishing point for the converging lines on the uphill street would be found above the vanishing point for the same lines when level.

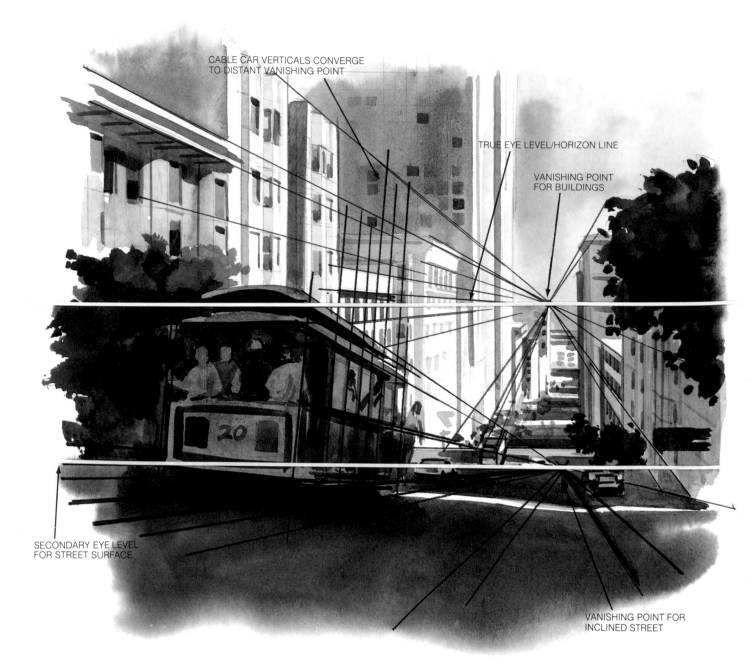

CABLE CAR VERTICALS CONVERGE
TO DISTANT VANISHING POINT

TRUE EYE LEVEL/HORIZON LINE

VANISHING POINT
FOR BUILDINGS

SECONDARY EYE LEVEL
FOR STREET SURFACE

VANISHING POINT FOR
INCLINED STREET

After the experiments in preliminary sketches, it was decided to widen the street to avoid a canyonlike scene. The middle-ground buildings on each side of the street are more interesting when seen at a less acute angle, and by simply widening the street, the basic perspective remains unchanged. At the same time, more detail is revealed on the fronts of the buildings. Since this view is basically in one-point perspective, the widening cannot be too extreme or the edges of the painting will appear distorted. In this subject, it's only necessary to extend the straight lines visible on buildings or on street surfaces until they intersect, clearly forming distinct vanishing points.

When each of the two vanishing points is located, a horizontal line for each eye level/horizon line can be drawn in. All shapes with true verticals and horizontals will have vanishing points on the true eye level. Any cube or boxlike form located on the inclined street surface will have vanishing points on the secondary eye level (for edges parallel to the street surface). The perpendicular edges will no longer be true verticals and will converge toward a very distant vertical vanishing point. In this case, with a downward-sloping plane, the vertical vanishing point is *above* the true eye level; in an upwardly sloping plane, the vertical vanishing point would be *below* it.

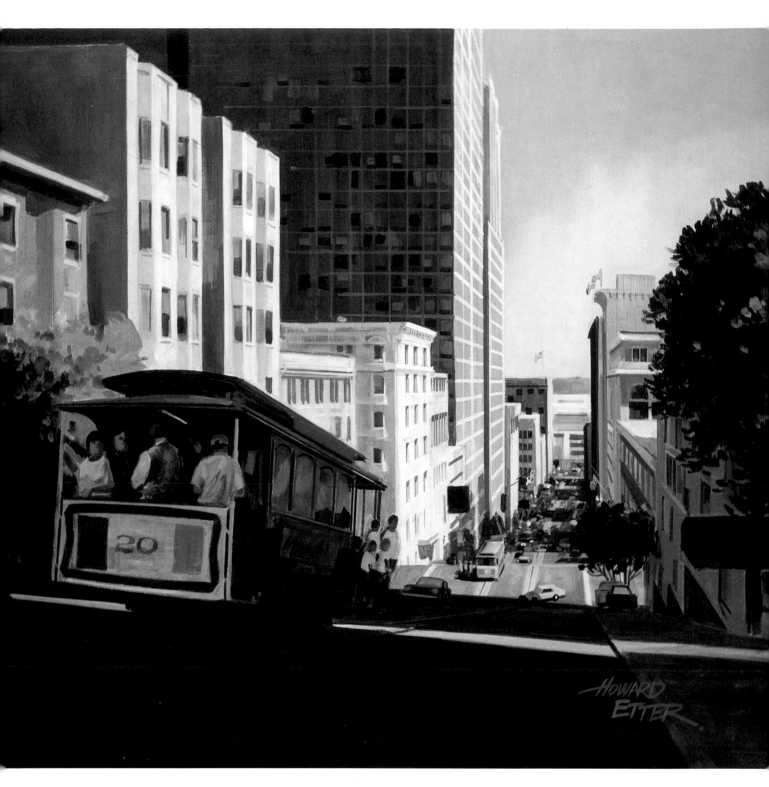

POWELL STREET, SAN FRANCISCO, *oil on canvas, 24" × 26" (61 × 66 cm).*
The finished painting shows a wide enough view so that the cable car can be included at its correct scale without dominating the composition or seeming to crowd the street. The strong sidelighting effect has been retained to take advantage of the receding bands of light and shadow that emphasize the impression of depth. The scale and placement of vehicles in the street also contribute to the feeling of distance.

A VIEW IN ONE-POINT PERSPECTIVE

Mackinac Island is a popular summer resort a short ferry ride off the northern tip of Michigan's Lower Peninsula. Tourist shops, narrow streets, and horsedrawn carriages (automobiles are prohibited) all add to the island's appeal. For the artist, much of Mackinac's charm lies in the random collection of buildings, in a great variety of styles, all crammed together to create a kaleidoscope of shapes, colors, and patterns in which the artist's imagination can have free reign. A view into a back courtyard offers possibilities worth developing into a composition and provides a good example of a simple yet interesting one-point perspective view.

In the illustrations above, we have a number of building shapes grouped together in different environments. The sketchbook studies of a vacation resort explore various combinations of buildings, sometimes to help isolate and identify the subject and sometimes to combine and recombine portions of the material in order to come up with a number of different ideas for a painting.

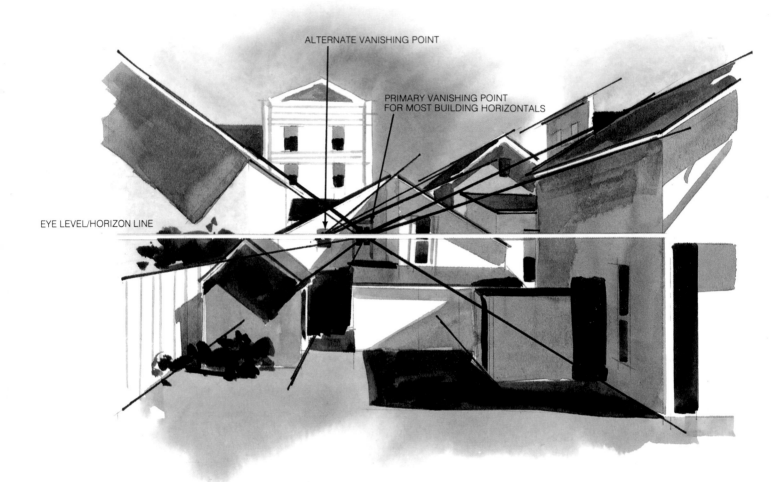

ALTERNATE VANISHING POINT

PRIMARY VANISHING POINT
FOR MOST BUILDING HORIZONTALS

EYE LEVEL/HORIZON LINE

Our main perspective consideration in this subject is to locate the
central vanishing point. With a straightedge, you can visually extend
the horizon lines of the buildings to where they converge on the
pane of glass in the door of the central building. This locates the
main vanishing point and also establishes the position of the eye
level/horizon line. Not all lines vanish here, but most do. There is
always the option of making some walls or roof lines vanish on the
same eye level/horizon line, even if they aren't parallel and even if
they have different vanishing points.

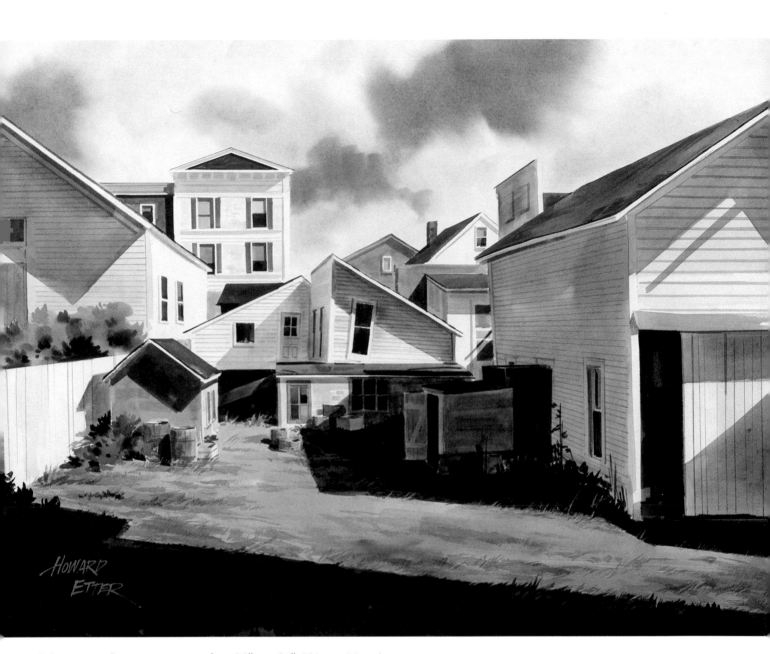

MACKINAC ISLAND, *watercolor, 20" × 26" (51 × 66 cm)*.
The completed painting shows a few minor changes from the
preliminary photograph. The angle of view has been widened to
include the end wall and door of the barn on the right and to allow
more space in the foreground. The white fence has been added on
the left, against the dark shrubs. A gable end added to a building
breaks the skyline in the distance, and a chimney and a building
false front have been eliminated to avoid visual confusion. Some
dark cast shadows in the extreme foreground suggest other unseen
buildings nearby.

A DISTANT SUBJECT

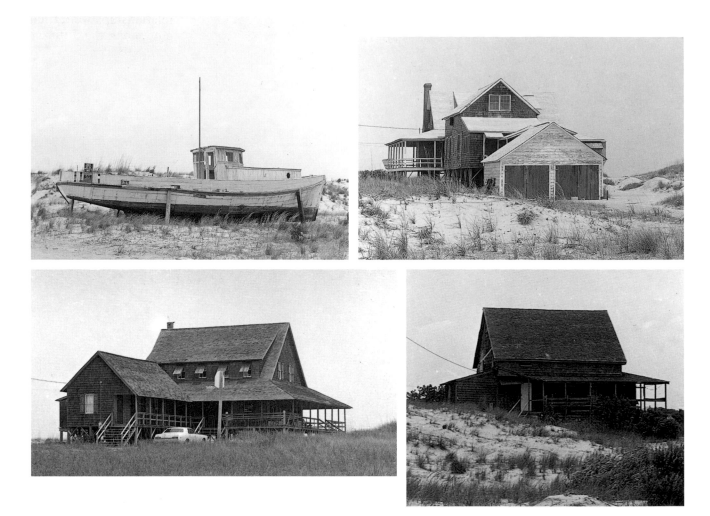

In this case, several separate photographs were used to incorporate a number of subjects—all typical of the sandy beach along the outer banks of North Carolina—into a single composition showing the perspective of a fairly distant scene. The final painting would include the large beach house with the boat in front and a few distant buildings at the crest of the dunes in the background.

In the sketches, various compositional ideas and perspective relationships were tried out among the different parts of the whole. The placement and angle of the buildings could be changed and redrawn to fit the overall perspective point of view of the painting.

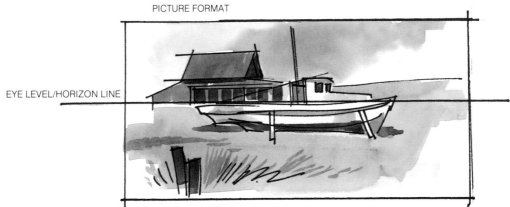

PICTURE FORMAT

EYE LEVEL/HORIZON LINE

MAIN SUBJECTS ROUGHED IN FOR POSITION

The first step in putting together this composition is to locate the placement and indicate the size of the two major elements—the house and the boat—and to rough them in on the picture surface. Since the thrust of the composition carries the eye to the middle distance and beyond, it's best to use fairly widely spaced vanishing points—at least three times the diagonal of the picture format. The wide vanishing points guarantee that the feeling of distance will not be lost if the viewer steps back a bit from the optimum viewing distance.

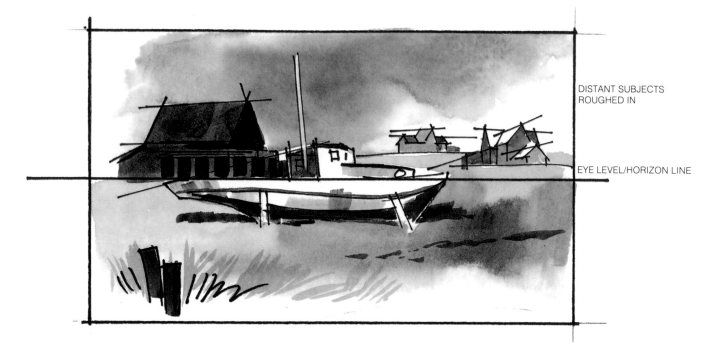

DISTANT SUBJECTS
ROUGHED IN

EYE LEVEL/HORIZON LINE

Here the most distant elements are roughed in, in the positions suggested by the sketchbook studies. Since the buildings are all quite far away from the picture plane, small changes in the placement of vanishing points for each may not adequately explain their nonparallel, or random, relationships to one another. But some effort must be made to convey the idea. Since the boat is also at a different angle from the main beach house, it should have its own set of vanishing points. To be consistent with the overall perspective, each building's set of vanishing points must be separated by a distance equal to at least three times the diagonal of the picture format.

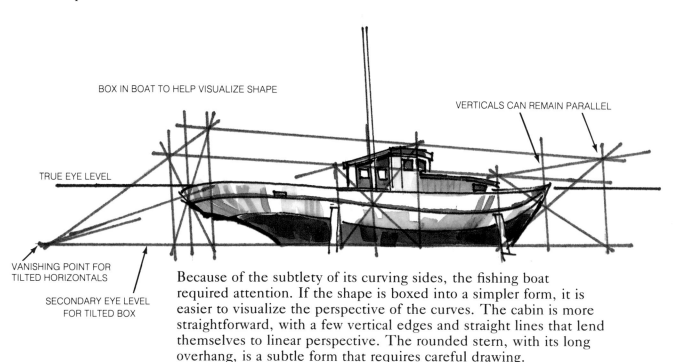

BOX IN BOAT TO HELP VISUALIZE SHAPE

VERTICALS CAN REMAIN PARALLEL

TRUE EYE LEVEL

VANISHING POINT FOR
TILTED HORIZONTALS

SECONDARY EYE LEVEL
FOR TILTED BOX

Because of the subtlety of its curving sides, the fishing boat required attention. If the shape is boxed into a simpler form, it is easier to visualize the perspective of the curves. The cabin is more straightforward, with a few vertical edges and straight lines that lend themselves to linear perspective. The rounded stern, with its long overhang, is a subtle form that requires careful drawing.

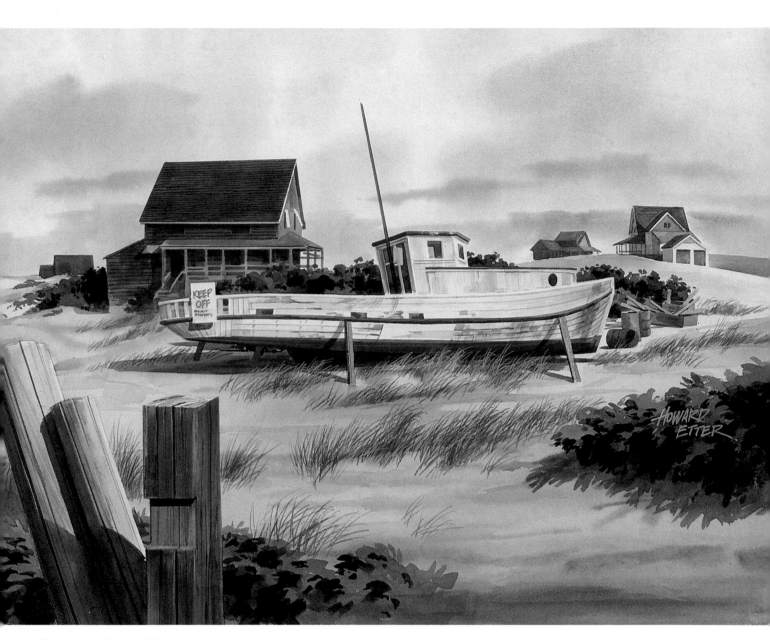

BEACH AT KITTY HAWK, *watercolor, 18" × 26" (46 × 66 cm)*.
The finished composition shows a combination of middle-ground
subjects and distant subjects, with the foreground taken up by
beach grass. The perspective effects employ both linear perspective
and the depth implied by overlapping forms, which helps push the
most distant beach houses well into the background. Their reduced
sizes, the overlapping of closer objects, and the very flat perspective
angle of the building horizontals all contribute to the feeling of
depth, which is further accentuated by the addition of a little
atmospheric perspective produced by slightly lowering the contrast
range in the distant houses.

A CLOSE SUBJECT

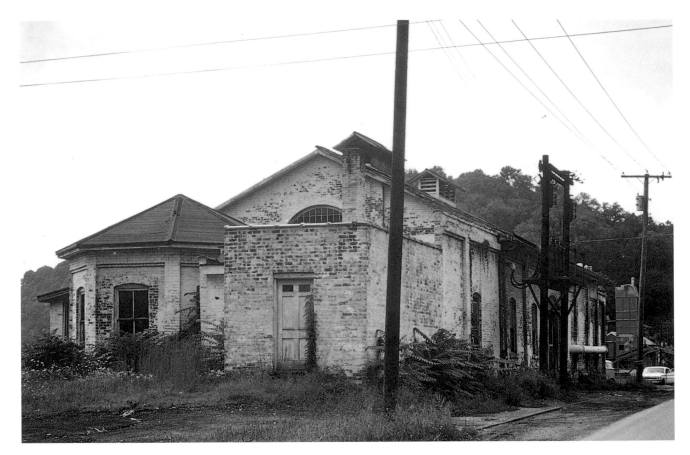

This is an aging but not abandoned water-pumping station on the Ohio River. Situated on a high bluff, it draws the water supply for several small riverside communities. When you see the building from the road, it holds little interest. Seen from the end, however, its shapes and angles offer a lot to work with. An old building like this, seen up close, is almost a still life subject in that the details and textures become more important because of the proximity. The peeling paint on the brick surface softens the mortar-joint patterns without obscuring them and at the same time creates a unique and varied texture.

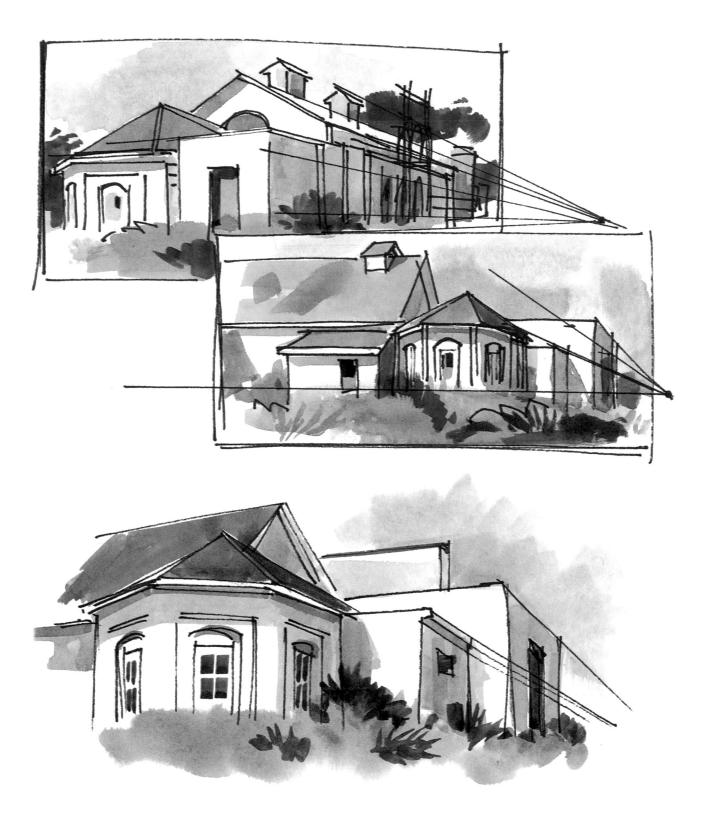

The sketchbook studies for this subject are directed toward solving perspective and compositional problems. Particular emphasis is placed on the use of light and shadow to develop form and create an interesting pattern of value changes. In these studies, one can decide such things as whether adding a foreground object would create more interest and emphasize the apparent depth within the picture area.

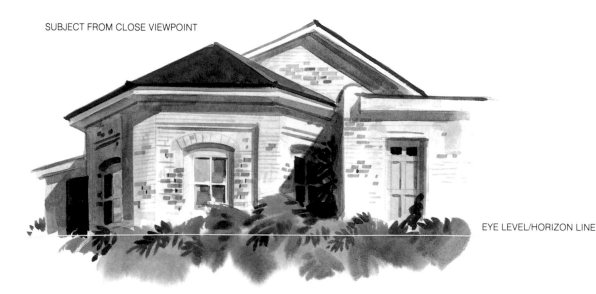

SUBJECT FROM CLOSE VIEWPOINT

EYE LEVEL/HORIZON LINE

Once you've chosen to close in on the octagonal windowed room, the main building masses can be roughly indicated and the eye level/horizon line sketched in. There are two ways to approach a close-up view, one of which is shown here. When working in the field, it's normal for the artist to find the station point that provides the desired arrangement of shapes. From this station point, a careful observation of the eye level and the angles of the converging horizontals will produce the normal perspective look that one sees in nature.

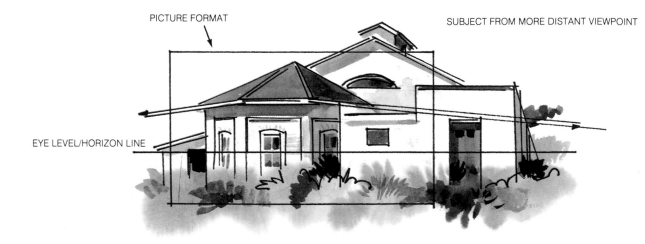

PICTURE FORMAT

SUBJECT FROM MORE DISTANT VIEWPOINT

EYE LEVEL/HORIZON LINE

The second way to close in on a subject is to work from a more distant station point and to close in visually rather than actually moving closer to the subject. When one draws the eye level and the converging horizontals from this more distant station point, the image is simply made large enough to fill the format as desired. This approach, which has the effect of somewhat flattening the implied space within the painting, is sometimes used because the distant view provides the best arrangement of shapes from a design point of view.

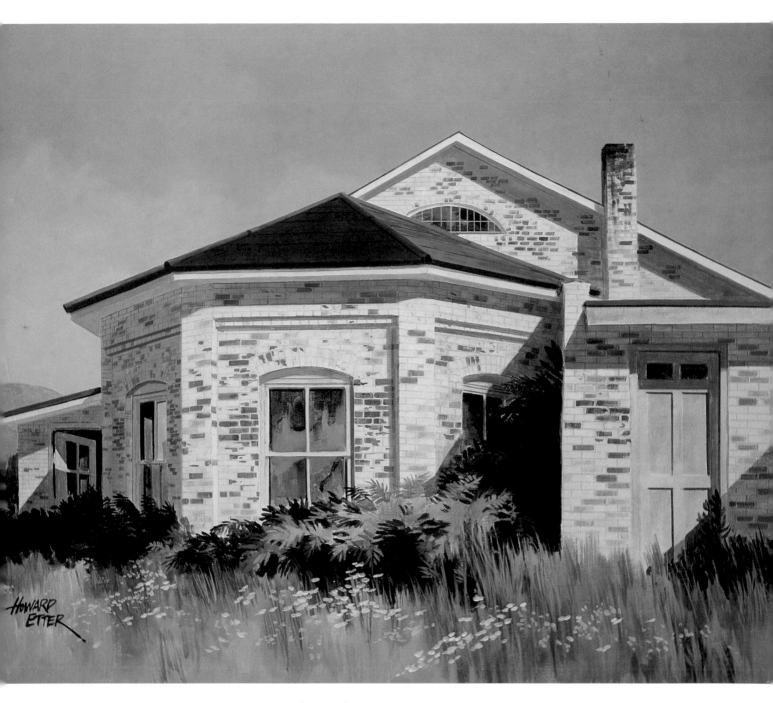

THE PUMP HOUSE, *oil/alkyd on canvas, 24" × 30" (61 × 76 cm)*.
As in many of the other demonstrations, the finished painting shows
some variations from the original subject. The right side of the
building has been altered to include a door where none actually
exists. In order to imply the forward projection of the right-hand
wing, the lighting has been changed to provide cast shadows
designed to bring out the building's forms in a more or less
three-dimensional way. The half-round window in the gable end
has been included as a useful detail, although it cannot be seen
from this close viewpoint. This close view of the building allows
more texture to be visible in the brick walls and more detail in the
window frames and the roof fascia.

TWO-POINT INTERIOR WITH SUNLIGHT

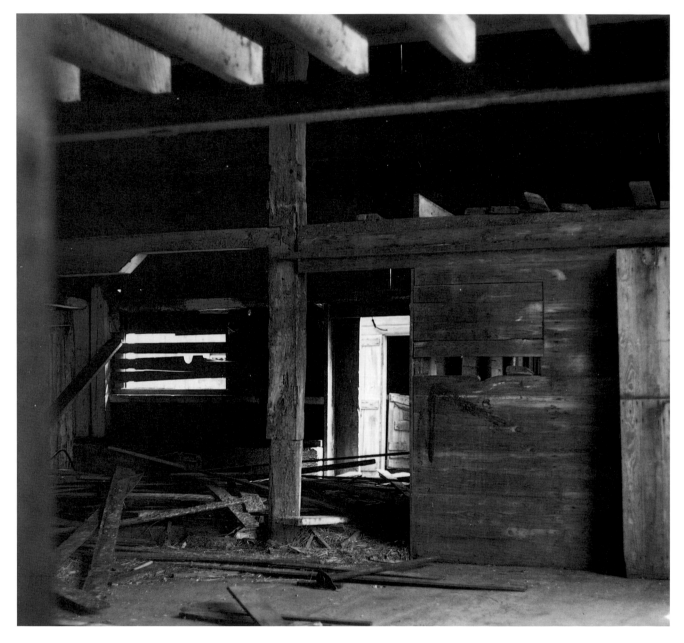

The original post-and-beam construction of old barns such as this was so good that they have often outlived their usefulness. In some areas, such as the Midwest where this barn is located, it's not worth the trouble to tear them down. They are left open to the weather and abandoned to their fate. For some artists, a structure like this is as interesting inside as it is outside. The removal or addition of walls, posts, doors, and windows creates random and unexpected variations in the original functional building plan, and openings in the building's "skin" allow sunlight to enter and make intriguing patterns. Best of all, on rainy days an abandoned barn provides shelter as well as subject matter!

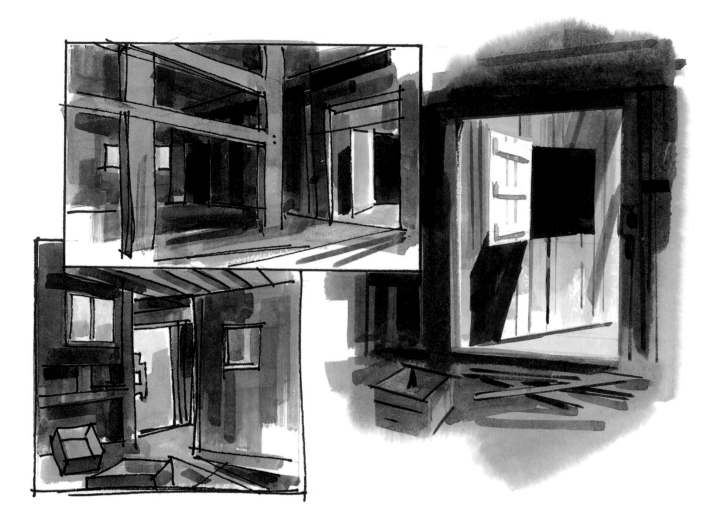

Here, sketchbook studies are used to study the complexity of the building and the structural forms inside the barn and, by simplifying the forms, to focus on possible compositions. Changing the angle of view slightly yields a number of very different results. This is a good time to experiment with changes or inventions, such as adding, deleting, or moving windows or doors, implying openings through which sunlight can stream into the interior, or showing views to the outside through doors, windows, or even gaps between the barn boards.

Interior spaces often seem unconvincing unless the drawing includes more area than would be covered by the normal 50-degree cone of vision. This means that some distortion will be seen toward the edges of the painting format. How much distortion is excessive is a matter of each artist's personal judgment. Usually, a cone of 75 degrees is maximum. This means that the spread between vanishing points will be about one-and-a-half times, and the optimum viewing distance about two-thirds, the diagonal of the format.

This interior gets a strong feeling of depth from the vanishing lines of the overhead beams. The back wall recedes to a distant vanishing point at left; the right-hand vanishing point is outside the picture limit. Bits of debris on the floor—which each have vanishing points, since they are at random angles—add to the impression of depth.

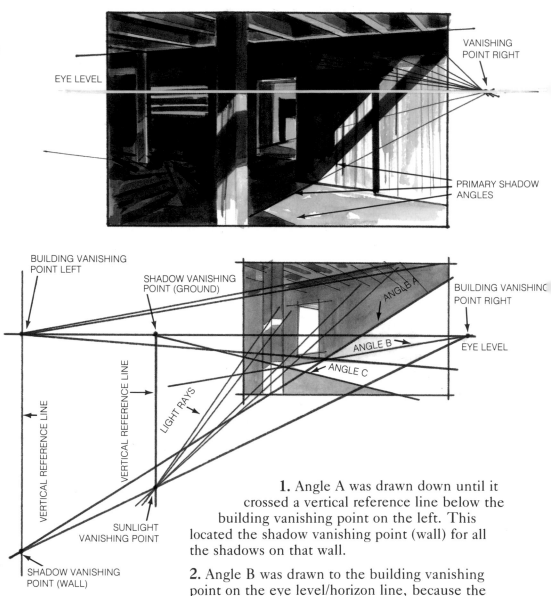

This diagram shows how the light-and-shadow angles were plotted for this subject. The shape of one of the major areas of sunlight having been chosen (you can also choose a major shadow area as starting point), the angles thus established were reference points for all the other sun/shadow areas.

1. Angle A was drawn down until it crossed a vertical reference line below the building vanishing point on the left. This located the shadow vanishing point (wall) for all the shadows on that wall.

2. Angle B was drawn to the building vanishing point on the eye level/horizon line, because the edge that casts the shadow vanishes there.

3. Angle C was chosen as the basic angle for shadows cast onto the ground plane by vertical edges. It was extended to the eye level/horizon line. Angle C makes the shadow vanishing point for all such shadows.

4. A vertical reference line was dropped from the shadow vanishing point and crossed with a line drawn between the shadow vanishing point (wall) and the opposite building vanishing point. The point of intersection is the sunlight vanishing point for all the light rays in the picture.

Even if you don't work them out accurately, be aware of these basic reference points and have a rough idea of their positions so that you can invent light-and-shadow effects in a convincing manner.

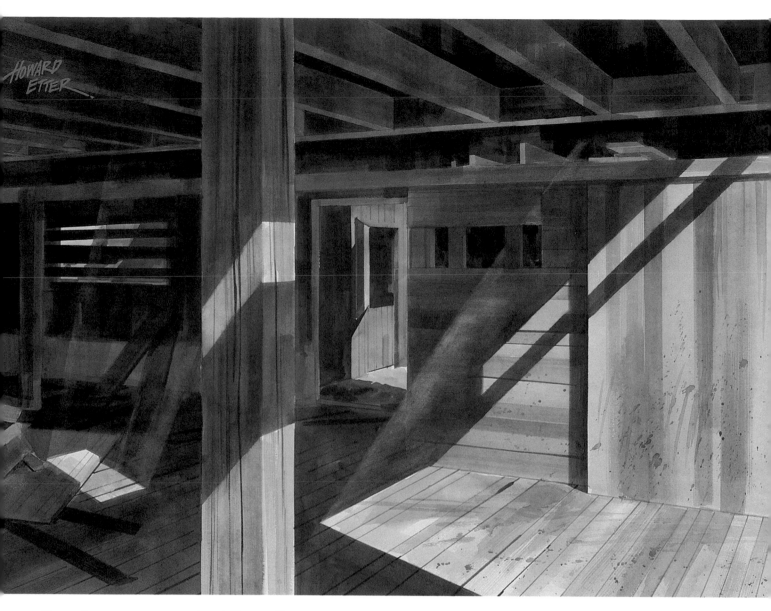

BARN INTERIOR, *watercolor, 18" × 24" (46 × 66 cm).*
For this subject light and shadow were used in a creative way as
well as to reinforce the perspective cues of the building's structure.
By assuming a dusty atmosphere, it was possible to paint not only
the sunlight falling on the wall and floor but also the rays of sunlight
themselves as they passed through the air and illuminated tiny
particles of dust floating in space. The light reflected from the sunlit
floor helps highlight the floor joists of the hayloft above and
provides better definition of an otherwise hard-to-see, rather gloomy
area.

NONLINEAR PERSPECTIVE

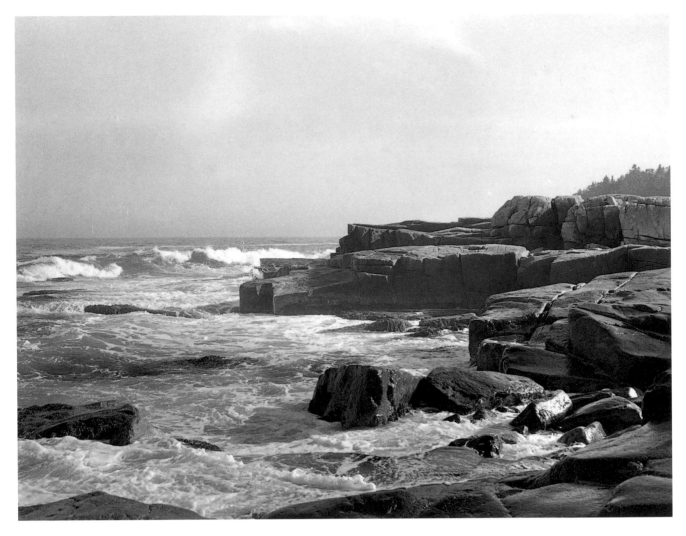

This photograph shows a typical landscape subject along the coast of Maine, with no buildings, wharves, or other manmade objects to indicate scale and depth. Natural forms give, at best, an ambiguous impression of size and space. Often situations like this occur, in which the impression of depth cannot be conveyed through the usual linear perspective devices. A variety of more subtle cues have to be used to do the job usually done by perspective lines of rectilinear objects.

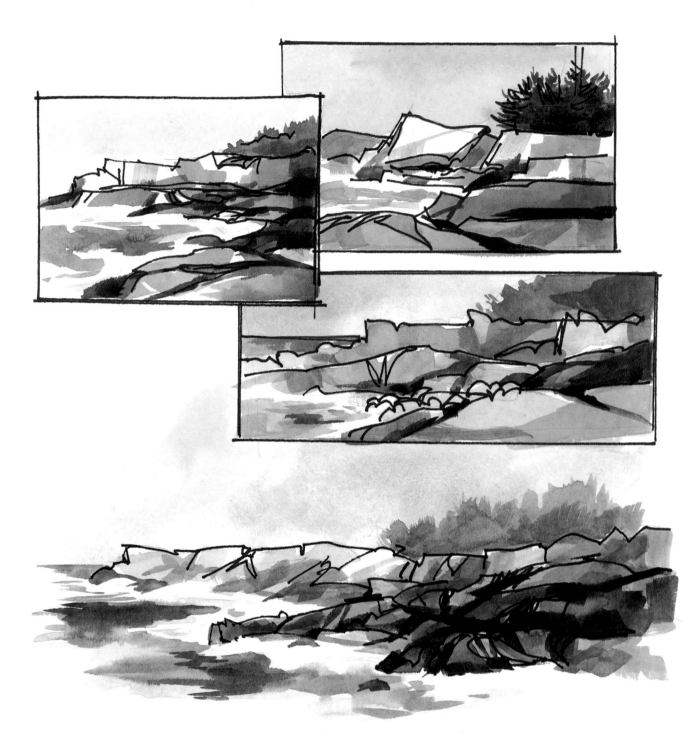

Subjects that lack straight-line objects require different methods to suggest depth. Here, preliminary sketches explore which natural forms can be used to imply space. Objects whose sizes are known, for example, can help establish scale. Overlapping forms suggest depth. Each subject warrants a different solution.

When you draw rocks, if you overlap the forms into a series of horizontal "bands," with each band diminishing in size as it moves away from the picture plane, you'll achieve the effect of depth. The detail and texture of each band must also diminish in size so that sharpness will be lost with each successive band.

For this subject, another possibility is to show depth by inventing figures engaged in a recognizable activity, such as gathering stones or shells, and have them diminish in size as they are placed farther from the picture plane. When inventing figures, pay attention to the way that you place them in your composition, relative to the eye level and to the planes (here, the irregular planes of the rock forms).

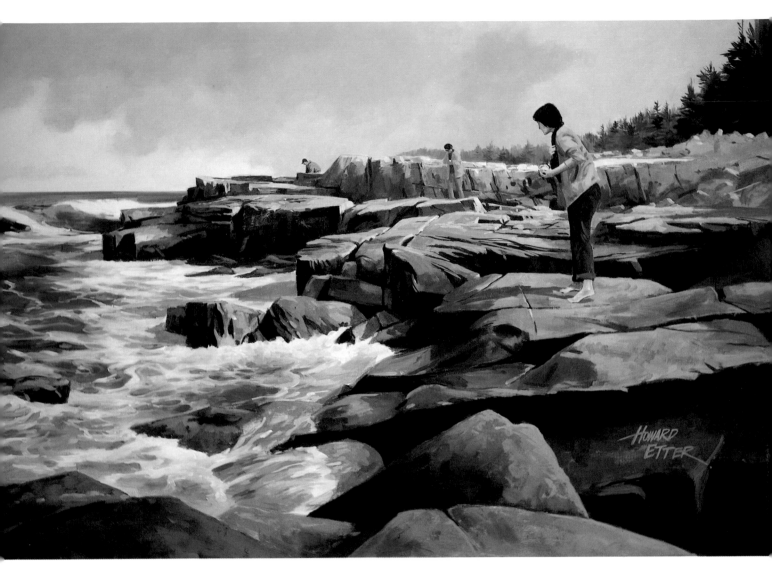

THE PENINSULA, *oil/alkyd, 24" × 36" (61 × 91.5 cm).*
The finished painting shows how effective the combination of visual
cues can be in suggesting depth in a painting, even when there are
no linear elements. The visible horizon—the eye level/horizon
line—is placed moderately high in the picture format. The sky and
distant trees are kept simple to shift the viewer's interest to the
rocks. Atmospheric perspective is used to achieve separation
between rocks in the foreground, rocks in the middle distance, and
trees in the background. Figures were kept small enough to provide
the necessary perspective cues. They also provided a basic scale
reference, and by diminution, an impression of depth.

Five
STILL LIFE

For many artists, the challenge of still life painting can be all-engrossing. The opportunity to create a small, self-contained world of visual delights is intriguing and can allow you to exercise your creativity in quite different ways than other subjects would. Still life compositions run the gamut from natural-looking groups of related objects to complex mixes of unrelated ones, and you may be focused as much on achieving interesting arrangements of objects as on rendering volume, texture, and space in the painting itself.

Still life painting, in addition to using all the basic elements of perspective found in landscape painting, requires a few extra techniques owing to the fact that still lifes are usually made up of (1) *objects placed at different angles* to the picture plane and to each other; (2) objects that are spherical instead of, or in addition to, cubelike forms, which means that you'll be drawing the *circle in perspective*; (3) objects lit by *artificial light* rather than by sunlight, which changes the way shadows are projected; and (4) objects that are sometimes placed on *inclined planes*.

Finally, because you'll be working much closer to your subject in still life painting than in landscape painting, you may be tempted to move your vanishing points close together. Don't. The rule that vanishing points must always be far enough apart to provide a comfortable viewing distance is true no matter what your subject is and no matter how close you are to your working surface or to your subject: vanishing points should be at least as far apart as twice the diagonal of your picture format.

OBJECTS PLACED AT DIFFERENT ANGLES

Since objects in a still life are apt to be arranged at different angles to each other and to the picture plane, each object will require its own perspective system within the context of the overall point of view of the painting. In addition, each object, if it's tilted up or down or angled away from or toward the picture plane, will require its own individual eye level on which to locate its vanishing points, again within the context of the painting as a whole.

One of the most crucial aspects of drawing grouped objects is to make sure they all relate to the same picture plane and the same station point; in other words, they should all look as if they belong in the same painting. Normally, you'll be able to draw the perspective relationships of your grouped objects from direct observation, but it can happen—especially when working from more than a single source or when you're inventing—that an object just won't "sit" where it belongs. In this case, it can be helpful to make a small-scale diagram like the one shown here, showing their positions relative to each other, the picture plane, and the station point, as outlined below:

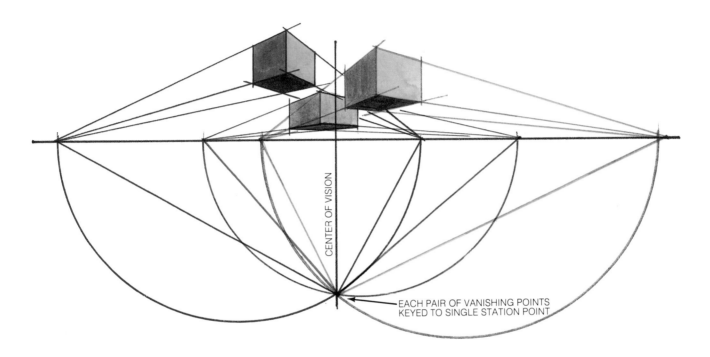

CENTER OF VISION

EACH PAIR OF VANISHING POINTS
KEYED TO SINGLE STATION POINT

1. First, rough out the forms in the size that they will be in your painting, locating the vanishing points for each. This will give you the dimensions you're going to be working with.

2. Now reduce your sketch, with each object in proportion, so that you have a format small enough to be able to diagram conveniently.

3. Taking each pair of vanishing points separately, divide the space between the points in half, using the midpoint as a center from which to inscribe a half circle from one vanishing point to the other.

4. Repeat this procedure for each set of vanishing points, laying them out in their proper ratios along a straight line that represents the picture plane as seen from above. The half circles are your "ground plan" for the locations of the station

points for each set of vanishing points. What we hope is that all three half circles will intersect at more or less the same point, and that a line drawn from this point perpendicular to the picture-plane line will touch the picture plane somewhere near the center of the group of objects. If this is *not* the case, it may be necessary to shift the positions of the half circles, and possibly change their diameters, which will of course change the spread between the vanishing points, until they do intersect at about the same spot. When you've completed the small-scale analysis, simply enlarge the resulting dimensions back to your working vanishing points and proceed with your painting. (Landscape painters will find that this same analytical process can be helpful when dealing with nonparallel objects in a landscape.)

THE CIRCLE IN PERSPECTIVE

The still life painter often deals with circular forms seen in perspective. Drawing a circle in perspective means that you'll be drawing it in various degrees of ellipse. You can do this freehand, of course, or you can use an easy mechanical method to make sure the circle has the right ellipse for the depth you want to convey. This method involves enclosing the circle within a square, tying them together with guidelines that they have in common, and projecting the square in perspective. Whatever depth you give your square will automatically be transferred to your circle.

If you look at the plan view of a square enclosing a circle shown here, you'll see that there are four natural points of reference between the two forms at the midpoint of each of the sides of the square, where circle and square touch. To make sure these reference points are exactly on-center, draw a diagonal from one corner of the square to its opposite corner, then repeat on the other side. This will give you an X. The point at which the two diagonals cross, the center of the X, is the exact center of your square. Now draw a true horizontal and a true vertical through this center point to form a cross. Where these lines meet the sides of the square will give you the exact midpoint of the sides. Since this grid of lines is the same for the circle as for the square, you will be able to see precisely what degree of ellipse is required for the perspective in which you've drawn your square.

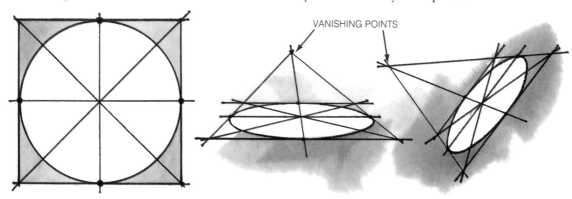

In most instances, this is all you'll need in order to draw a circle in perspective. However, for very large circles or for circles you want to be entirely accurate, there are four additional reference points where the circle crosses the diagonals of the square. To find these points, draw a small square inside the larger one, rotating it 45 degrees so that the sides are parallel to the diagonal of the outer square and the corners are touching the midpoint of its sides. If you look at the flat diagram of this square within a circle within a square shown here, you'll see a simple relationship between the points where the circle crosses the diagonals of the outer square and the points where the sides of the inner square cross those same diagonals. The circle crosses just inside the midpoint of the portion of the diagonal from the outside corner to the side of the inner square. In practice, this means that you have only to draw the outer square in perspective, draw the rotated square inside it, and estimate by eye where the midpoint lies between the side of the inner square and the outer end of the diagonal of the outer square, to get a reference point for judging the curve of the enclosed circle.

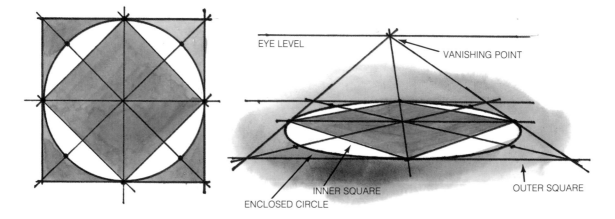

Here's how to apply this circle-in-a-square method to any freehand drawing, either to find the correct ellipse or to check on the accuracy of your drawing.

1. Rough in the shape you think your circle should have.

2. Enclose this circle shape in a square drawn in either one-point or two-point perspective, depending on the requirements of your subject.

3. Mark the center of each side of the square by drawing diagonals and vertical and horizontal centerlines. Make sure the shape is a true square, *not* a rectangle. Modify it and redraw your lines until it's true.

4. If necessary, work out the process with the rotated square to find additional reference points to "true up" your circle.

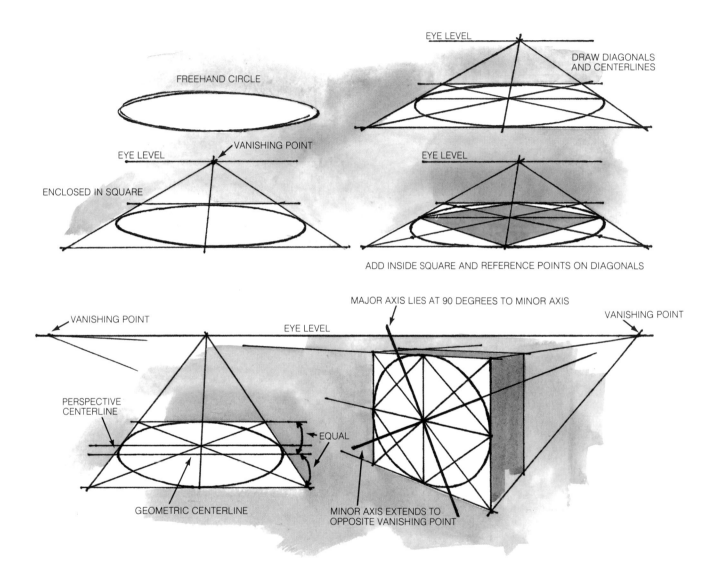

When drawing circles in perspective, it's useful to understand that the horizontal centerline of the enclosing square and the major axis of the circle in perspective do *not* coincide. As the circle comes forward past the horizontal centerline of the square, it continues to widen a bit until it passes the major axis of its elliptical shape and begins to recurve to the vertical centerline. In other words, the widest part of the ellipse is centered, top to bottom, whereas the perspective centerline is not.

When a circle is drawn on a vertical plane in two-point perspective, the resulting ellipse has its major and minor axes tilted. The top and bottom of the enclosing square are drawn to one vanishing point, while the sides remain vertical. Diagonals are drawn, then the inner rotated square. The minor axis is located by striking a line through the center of the square to the opposite vanishing point (the one used by the overall shape). The major axis is then drawn at a right angle to this line.

ARTIFICIAL LIGHT

In still life subjects, as well as in much figure work, the light source is often artificial and contained within the same space as the subject. Because the light source is close, the light rays are not parallel but radiate outward in all directions. And this changes the way shadows are projected and alters the location of the shadow vanishing points. With artificial light, the position of the light source and the shadow vanishing point must be plotted separately on every surface upon which a shadow is cast. On each such surface, shadows cast by perpendicular edges will radiate outward from a shadow vanishing point directly *underneath* the light source. Shadows cast by horizontal edges

(i.e., edges parallel to the surface receiving the shadow) will converge to the same vanishing point as the edges that cast them, just as with sunlight.

In order to find the position of the shadow vanishing point for each surface, draw vertical and horizontal tracer lines, in perspective, from the light source to the walls, and around the walls to include all the surfaces, as shown in the diagram. Shadows are developed by drawing perpendicular lines to any surface, drawing the shadow edges from the shadow vanishing point, and ending the shadow length by tracing the path of the light rays from their source, past the end of the perpendicular line, until it intersects the shadow line.

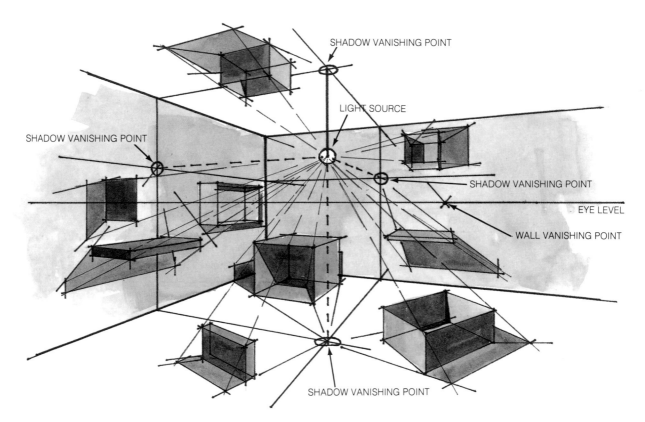

The most interesting shadows for still life painting are those cast from a light source in front of or to the side of your setup rather than from behind you. When the source is in front of you or to the side, it's visually accessible; its position can be plotted and direct lines drawn to establish the lengths of the shadows, which means you'll be able to plot your shadows accurately and experiment with unusual angles and effects.

When the light source is behind you, the shadows cast by artificial light begin to look a lot like those cast by sunlight. In plan view, the shadows diverge, or move apart, but when viewed through the picture plane they will converge to a

vanishing point. This seeming contradiction is caused by the angular relationships between the light source, the observer's eye, the picture plane, and the light rays reflected back to the eye by the subject. The observable differences between sunlight and artificial light in this particular situation are so slight that the most practical course is to treat them the same.

Whenever possible, of course, you should draw shadows from direct observation. If you understand something about what you're observing, however, it will be much easier for you to make sense of it and use light and shadow to its full creative potential.

INCLINED PLANES

Drawing objects that are tilted or resting on inclined planes introduces an extra vanishing point for "verticals" that would not normally converge. Usually, the convergence of the tilted verticals can be drawn by eye, but at times it's helpful to have a more exact idea of where to locate the extra vanishing point.

If the object is tilted on one side only, one vanishing point will be on the eye level/horizon line for the composition, and the other will be either above or below this, depending on the degree of tilt. The vanishing point for the verticals will be located on a *vertical vanishing trace* drawn through the extra vanishing point. You'll have to

exercise visual judgment in locating the extra vertical vanishing point far enough from the regular eye level/horizon line in order to give the needed convergence to the verticals without their becoming too extreme.

The diagram below shows the approximate relationships involved. You'll notice the secondary eye level drawn through the vanishing points for the inclined plane. You can use this to locate vanishing points for the "horizontal" lines on the inclined plane and parallel to it. If the plane is tilted in both directions, this secondary eye level is drawn between both vanishing points, and the angle it assumes will be dictated by their position.

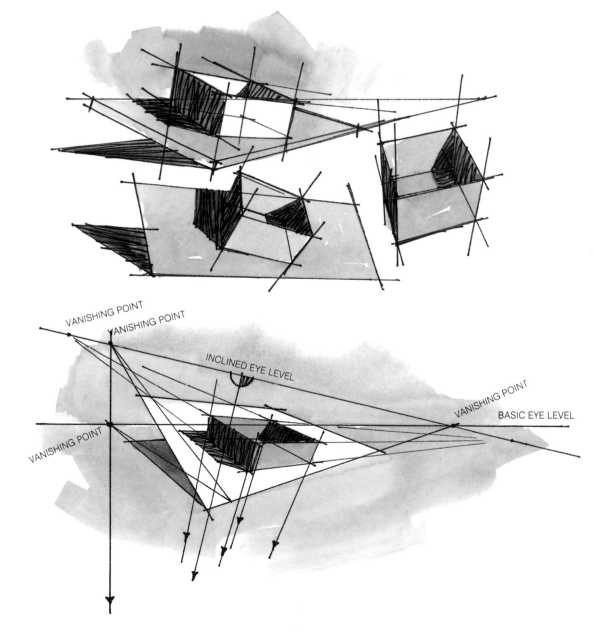

SIMPLE FORMS WITH
SINGLE LIGHT SOURCE

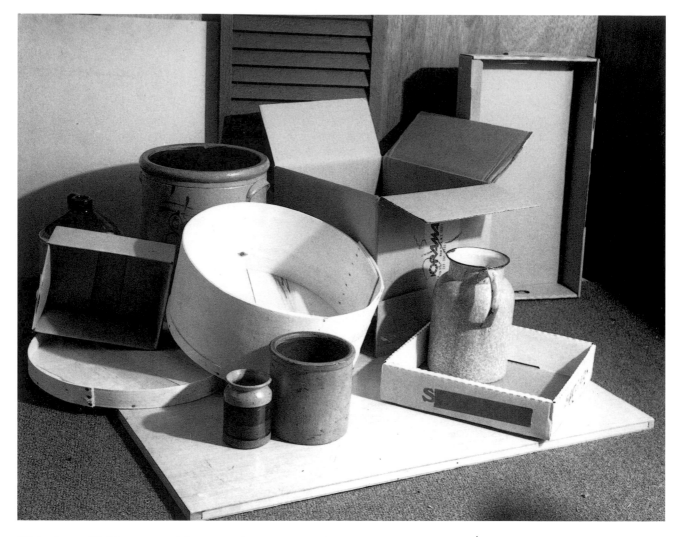

This first still life composition contains a group of very simplified three-dimensional forms lit by a single nearby light source that provides well-defined cast shadows. Some distortion is evident in the ellipses on the jugs in the foreground but not enough to be distracting.

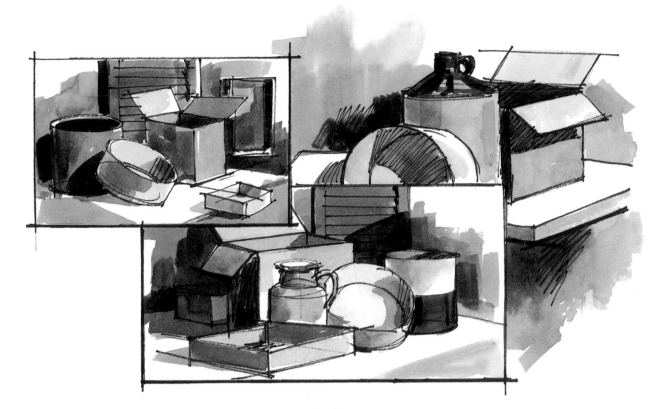

Studies for still life painting can have a number of different functions. In this instance, when a few potential arrangements were roughed out, the objects were placed and lighted, then shifted around to determine how well the previsualization would work. Except for some changes in shadows, the first sketches turned out to be reasonably close to the final arrangement.

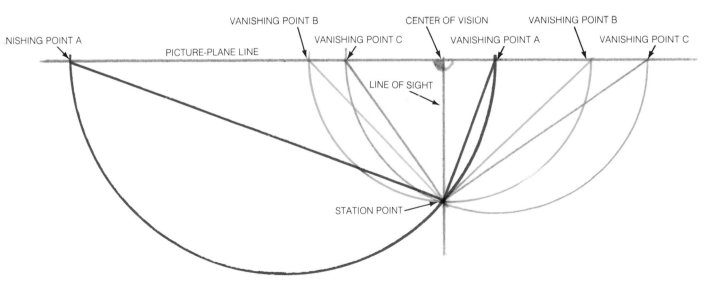

VANISHING POINT B CENTER OF VISION VANISHING POINT B
.NISHING POINT A VANISHING POINT C VANISHING POINT A VANISHING POINT C
PICTURE-PLANE LINE
LINE OF SIGHT
STATION POINT

Since the three main rectangular shapes are important clues to the basic perspective of this composition, their positions and vanishing points were roughed in first and then worked up as a separate small-scale diagram that analyzes relationships among vanishing points vis à vis overall eye level/horizon line and station point. This kind of analysis, though not always needed, is an easy way to solve problems when they arise.

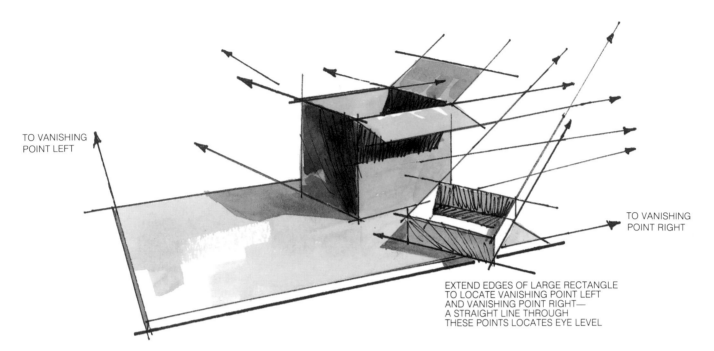

EXTEND EDGES OF LARGE RECTANGLE
TO LOCATE VANISHING POINT LEFT
AND VANISHING POINT RIGHT—
A STRAIGHT LINE THROUGH
THESE POINTS LOCATES EYE LEVEL

After working out individual vanishing points for each object, their
shapes were refined. The reference photograph shows a slight
convergence downward of the vertical edges, but this effect is not
really noticeable with actual objects unless the eye level is
somewhat higher than it is here.

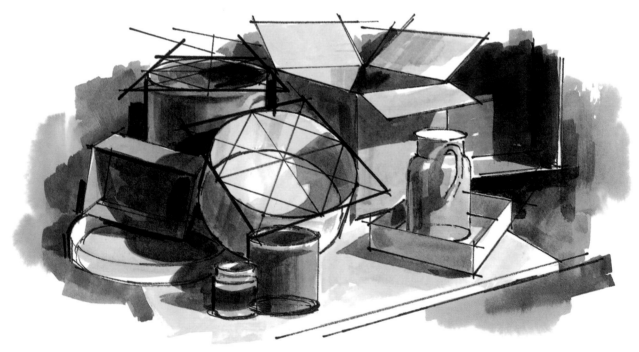

The rounded forms were roughed in, judging size and placement to
fit the rectangular shapes. Top and bottom ellipses of the vertical
cylinders can be drawn by enclosing them in perspective squares.
Squares can be drawn in either one-point or two-point perspective,
using the vanishing points for the large board. When you draw
ellipses, draw the complete shape, not just the visible part. Since
the cheese box is tilted, the vanishing point has to be raised above
the eye level/horizon line in keeping with the tilt of the form.

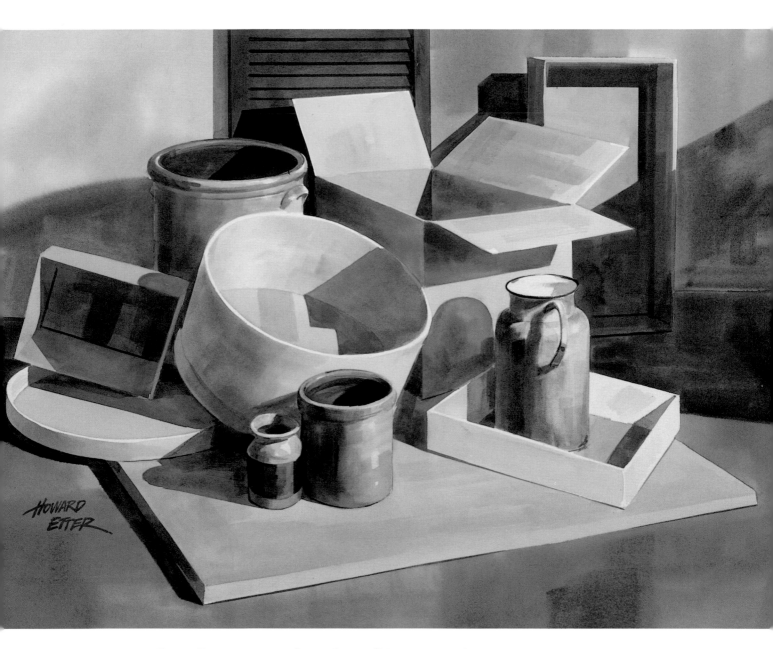

STILL LIFE WITH BASIC FORMS, *watercolor, 20" × 26" (51 × 66 cm).*
The finished painting shows a loose but literal approach to still life.
Although modified a bit, the simple shapes still look pretty much
like the initial subject. Extra shadows have been added in the
background to serve as a foil for foreground objects. Since the
arrangement was lighted to define the forms as well as possible, the
light and shadow seems to need only a minor adjustment. Changes
in shadow values brought out more contrast. The black-topped jug
at left, lost in shadow, contributed little, so it was eliminated.

VARIED OBJECTS WITH INCLINED PLANES

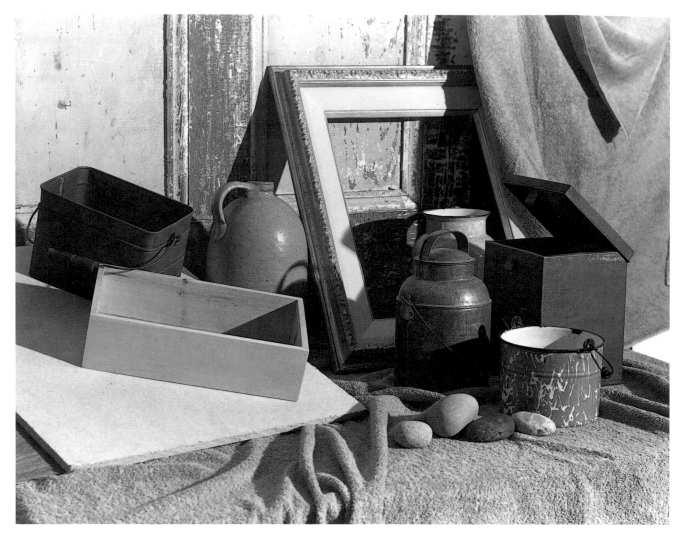

This subject includes a varied group of objects arranged in such a way as to show a number of inclined planes. Lighting is simple— from a single nearby light source. The large inclined plane at left is level along the front and back edges and tilted up to the left. There is a similar tilt in the picture frame, with different angles. The tilted edges vanish to a point high above the eye level/horizon line.

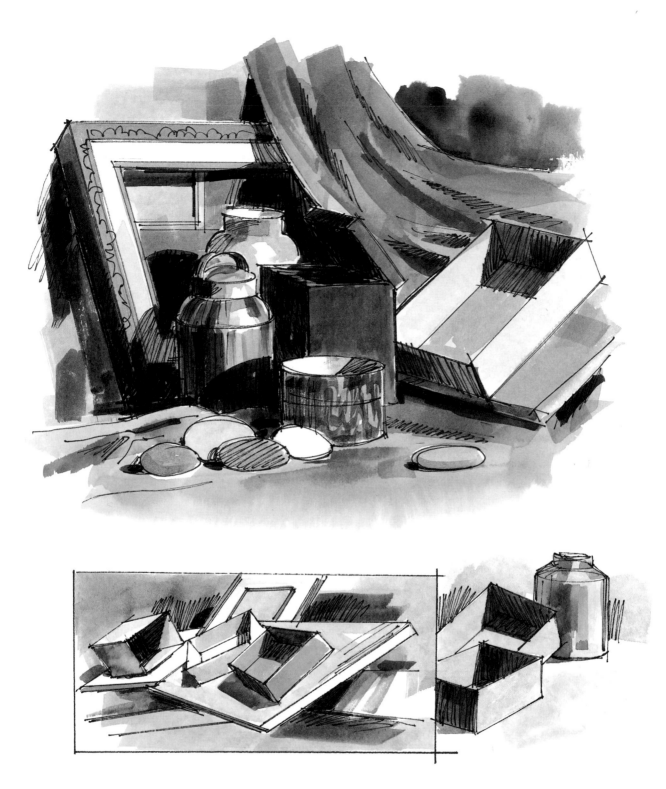

Drawing objects on inclined surfaces is more of a challenge than drawing the inclined planes themselves. Sketchbook studies can be used to try variations in the amount of incline and to judge how much convergence, if any, to use in drawing the normally vertical edges, which are now tilted off vertical. There is a precise method of locating the vanishing points for these verticals (see *Inclined Planes* on p. 95), but sketching them freehand will help you develop and improve your perception, as well as your imagination, when working with inclined or tilted shapes.

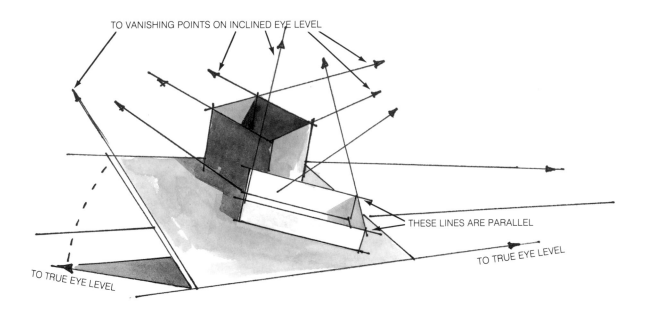

This sketch shows the relationship between the true eye level and the vanishing point for the level edges, the inclined vanishing point for the inclined edges, and the inclined eye level, which was diagrammed on p. 97. If you use a rough sketch to locate vanishing points and the inclined eye level, you can draw the inclined horizontals to lie flat on the inclined surface, and the verticals will converge correctly.

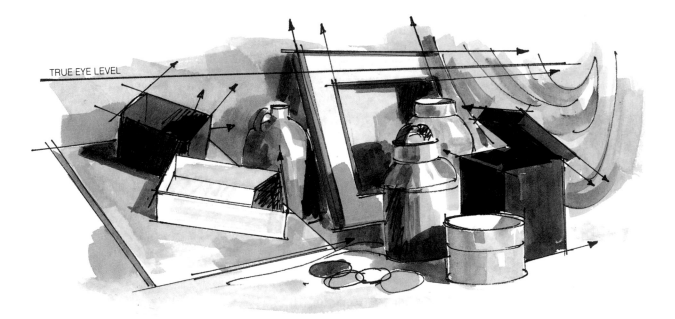

Here, converging verticals vanish to a point much above eye level. Horizontal edges vanish to a point on the true horizon but one different from that for the inclined plane. The tilted lid for the dark box has edges that are true horizontals and vanish to the true eye level. Inclined edges will vanish to a point *below* the right-hand vanishing point for the box.

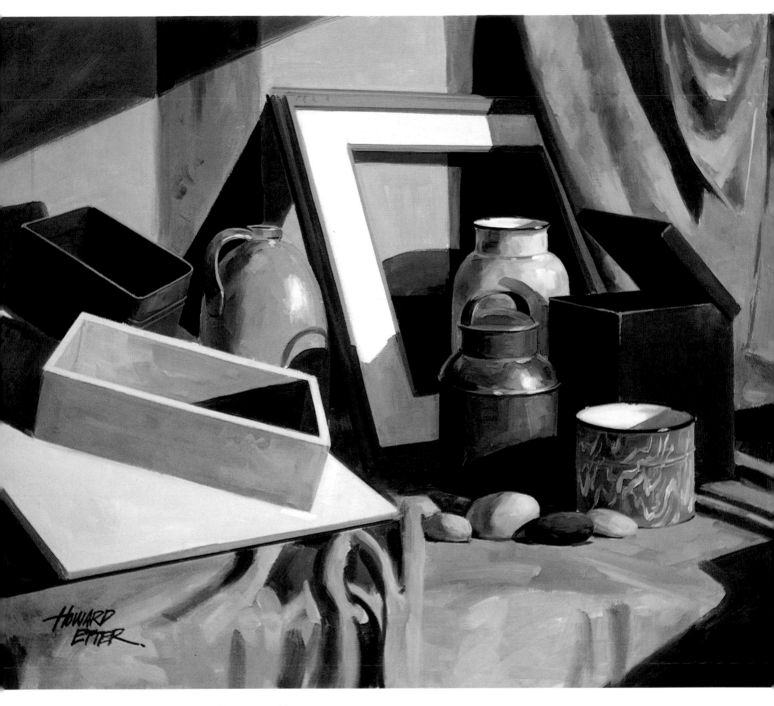

STILL LIFE WITH PICTURE FRAME, *oil on canvas,*
20" × 24" (51 × 61 cm).
The final painting shows a few differences from the initial setup.
Some shadows were changed; some were added. The glazed pitcher
sitting inside the picture frame is taller. Despite changes in size and
placement of individual objects, each object, whether tilted or level,
is related to its correct eye level. Shadows, even when introduced as
compositional devices, have been plotted as realistically as possible.

LIGHT AND SHADOW PATTERNS

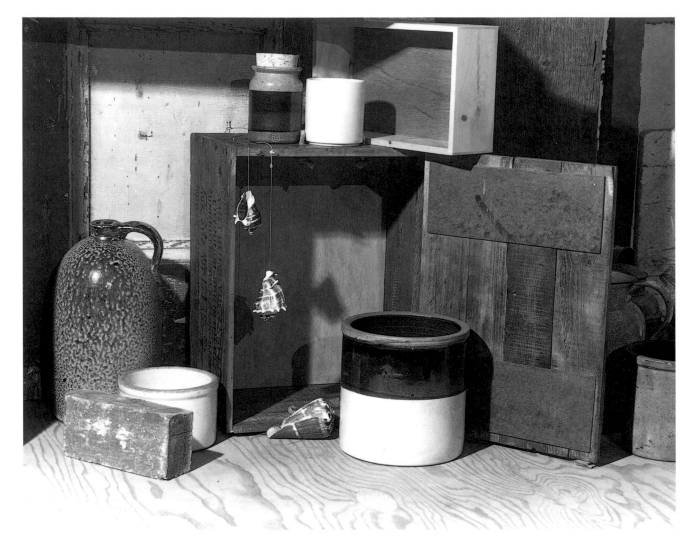

This still life was set up to explore basic patterns of light and shadow. We've combined simple boxlike forms with cylindrical shapes to keep the drawing simple so that we can concentrate on the light-and-shadow effects. The subject is lit by one main light off to the left but in front of the camera position, which produces clearly defined shadows. A "fill" light was used, well behind the camera, to hold some of the detail within the shadow areas. The shadows within shadows caused by this fill light were not intended as design elements and should be ignored.

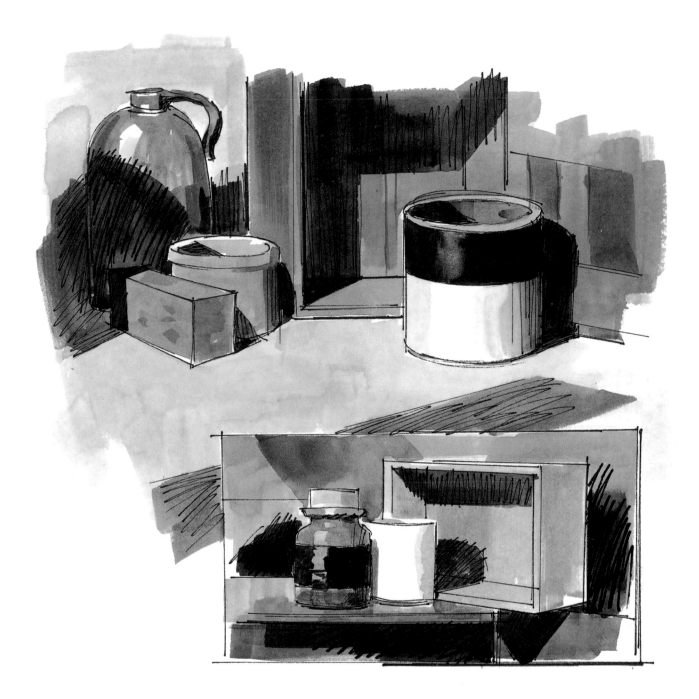

Isolating individual objects or groups of objects is helpful for studying perspective problems in easier combinations. Preliminary sketches allow you to rearrange objects without altering the existing setup. Manipulating light and shadow in sketches is often more revealing to the artist than actually shifting the light source to different positions. Sketching alternative shadows, while studying existing ones, can be the best method by which to choose suitable lighting. Shadows can be moved arbitrarily and altered to improve the composition or clarify the forms. Your sketchbook notes will help you discover how to manipulate them without losing the sense of reality. The two small jugs on top of the box could function as a separate composition, with the small box and cast shadows providing additional interest.

The nearby light source casts definite shadows across the tabletop. Extending the shadow edges back toward the light source will locate the shadow vanishing point for all similar shadows on that level. This angle was used to cast the major shadow inside the large box. The angle from the upper left-hand corner of the box to the shadow corner inside the box reveals the angle of the light rays, which provides the reference angle for drawing the other shadows. The light rays radiate outward from the source located above the shadow vanishing point.

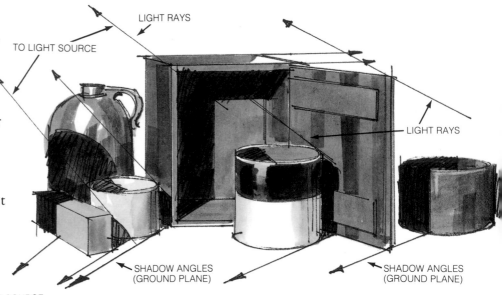

After you locate the major angles for shadows and rays of light, you can draw the smaller objects and their shadows, making any desired changes as you go along. Since the light source has been located, as well as the basic shadow angle, you can add shadows or move them around to enhance your composition.

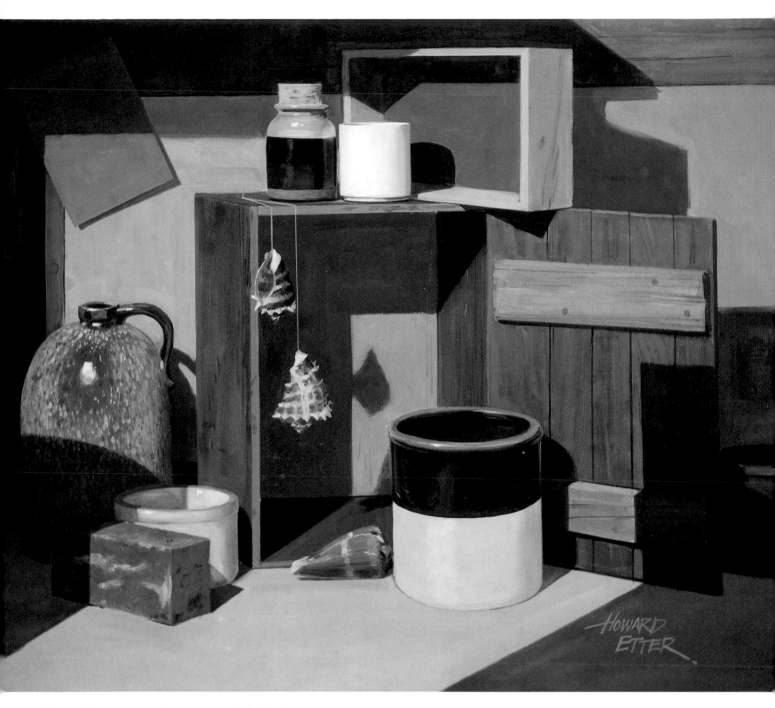

STILL LIFE WITH SEASHELLS, *oil/alkyd on canvas,*
20″ × 24″ (51 × 61 cm).

As usual, the finished painting shows changes and adjustments. The main emphasis is on the open box and the seashells. The shadow inside the box may seem a bit odd at the upper right-hand side because the diagonal cast shadow comes from behind the vertical edge of the door. This happens because the door is actually offset from the right-hand side of the box. Since it doesn't seem to confuse the eye, it was left unchanged. Sizes have been altered somewhat in the cylindrical forms. Some extra shadows were added across the tabletop. The shadow on the left was changed to help separate the large jug from the objects in front.

FIGURE

A fascination with the human figure, especially the nude, is an integral part of the tradition of realism in the West, and the ability to accurately draw the figure in the round has long been a gauge of an artist's mastery of the finer points of perspective. With no straight lines or right angles that lend themselves to linear perspective, showing the human body, or parts of the body, receding in space is a skill in its own right and requires both subtlety in depiction and careful observation of life.

All the elements of perspective covered so far apply as well to figure painting, but drawing the human body in perspective calls for something more. You have to be able to see *the figure as a combination of geometric forms* that exist in space in relation to one another and to the picture plane. Also, you have to use *light and shadow* creatively to define and clarify the various forms.

Demonstrations in this chapter, unlike those for the landscape and still life chapters, do not begin with a photograph showing the original subject. Rather, these demonstrations were done from life to approximate the actual conditions under which most figure work is done. With this subject, you really do have to "draw what you see." Although you can use photographic sources, the human body comes to life only when you're face to face with the real thing. For this reason, most artists paint the figure directly from a model or from sketches made from life.

THE FIGURE AS GEOMETRIC FORMS

When perspective is applied to the figure, it's often called foreshortening because of the way in which forms that recede in space seem to be "shortened" relative to how perpendicular they are to the picture plane; the more nearly at a right angle they are, the more foreshortened they will appear. This foreshortened quality is most noticeable when any long part of the body (fingers and toes, arms and legs, even the entire length of the body shown reclining) points straight out at the viewer.

As with the more complex shapes found in landscape and still life subjects, it helps if you visualize the various parts of the figure as being enclosed within simple geometric forms—such as cylinders, spheres, and boxes—that you can see and draw in terms of straight linear perspective. You can even draw the figure as if it were made up entirely of modified geometric shapes, like a wooden mannequin, until you become comfortable with manipulating these forms in space and learn how to position them in various angles and combinations.

With practice, you'll soon begin to see the human body in terms of large masses and simplified shapes, without being distracted by details. It will become clear to you why an arm pointing toward you appears to be short or why a leg on the far side of the body is entirely or partially hidden from view. You'll be able to see the twist in the body, upper section turned one way and lower section the other, and how every movement is counterbalanced by an opposing movement in order to stabilize the whole. By seeing the human body in terms of these simple forms and relationships first, you won't become overwhelmed, and its amazing complexities will fall into place with a minimum of confusion.

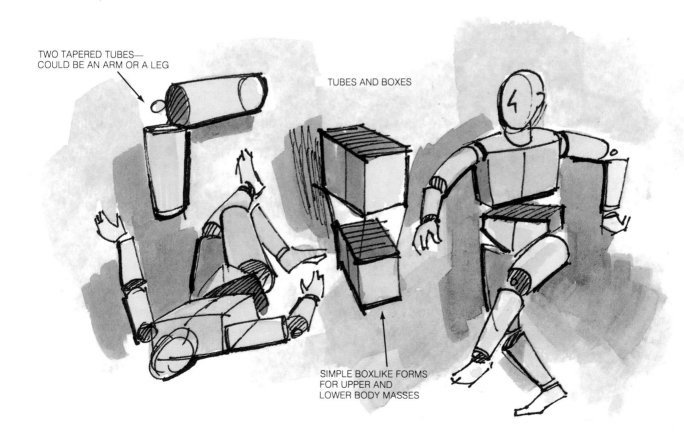

TWO TAPERED TUBES—
COULD BE AN ARM OR A LEG

TUBES AND BOXES

SIMPLE BOXLIKE FORMS
FOR UPPER AND
LOWER BODY MASSES

FIGURE 109

SIMPLE MANNEQUIN FIGURE

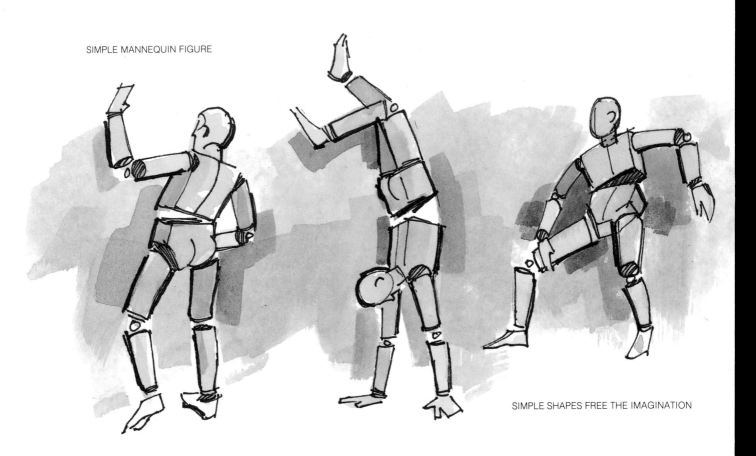

SIMPLE SHAPES FREE THE IMAGINATION

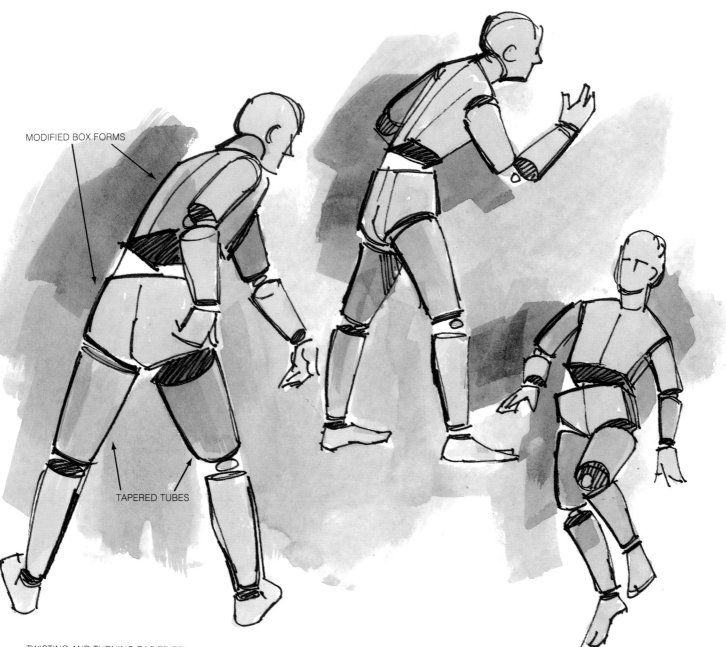

MODIFIED BOX FORMS

TAPERED TUBES

TWISTING AND TURNING EASIER TO
VISUALIZE WITH SIMPLIFIED FORMS

FIGURE 111

LIGHT AND SHADOW

In figure painting especially, the impression of three-dimensional form can be greatly enhanced by the intelligent use of light and shadow. The information on this subject covered in relation to geometric forms relates to the figure as well. (See *Artificial Light* on p. 94.) You may find that when parts of the body are foreshortened, however correctly, the effect may still not be clear.

Judiciously placed cast shadows and half shadows can be employed to delineate the curving cross section of a foreshortened form so that you achieve the impression of volume. Shadows can

also be used to separate overlapping forms and increase the perspective effect generally.

When using light and shadow in figure painting, the primary consideration is to locate the source of the light so that you can plot the resulting light rays and the cast shadows. It's also important to identify your basic shadow angle, that is, the angle of the vertical shadows across the ground plane as they converge to a shadow vanishing point. This will make it possible for you to invent or modify cast shadows on the figure in order to clarify and heighten the forms.

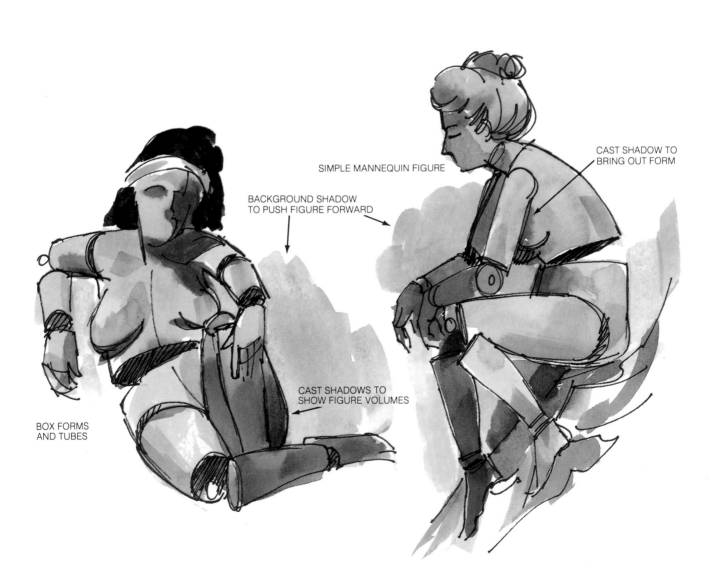

SIMPLE MANNEQUIN FIGURE

CAST SHADOW TO
BRING OUT FORM

BACKGROUND SHADOW
TO PUSH FIGURE FORWARD

CAST SHADOWS TO
SHOW FIGURE VOLUMES

BOX FORMS
AND TUBES

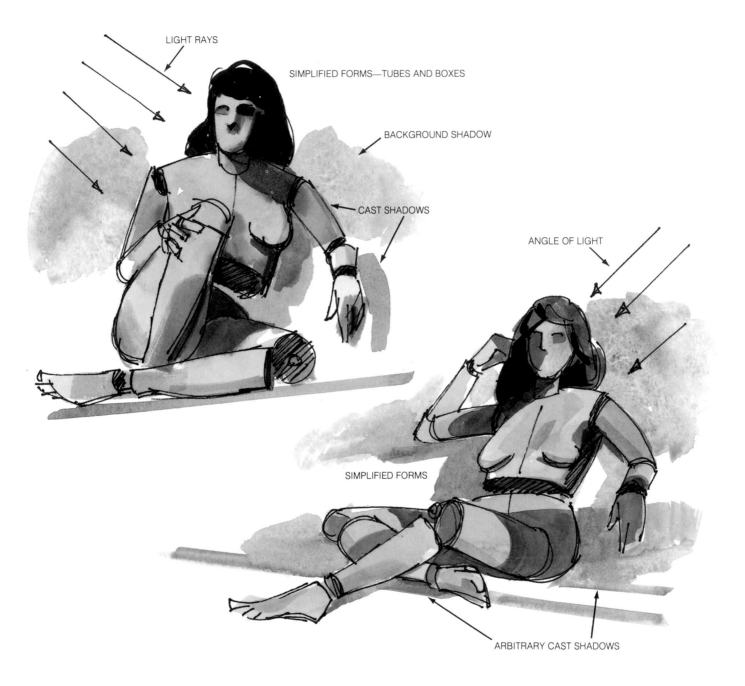

LIGHT RAYS

SIMPLIFIED FORMS—TUBES AND BOXES

BACKGROUND SHADOW

CAST SHADOWS

ANGLE OF LIGHT

SIMPLIFIED FORMS

ARBITRARY CAST SHADOWS

FIGURE 113

SEATED FIGURE

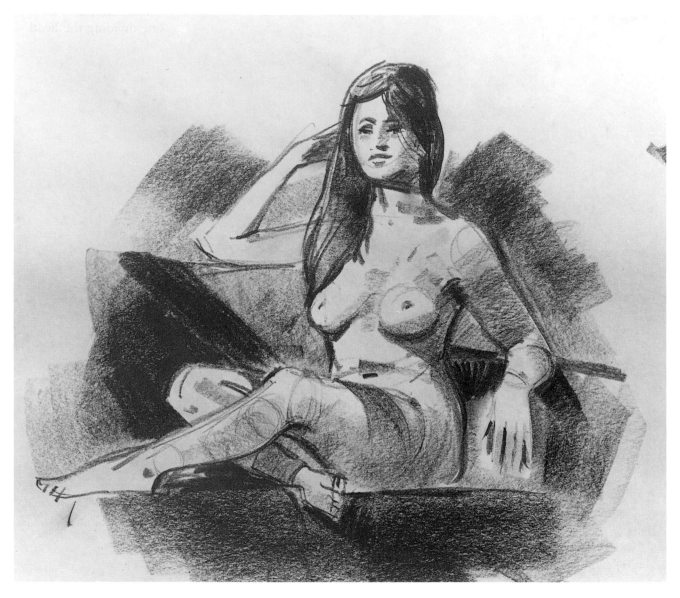

This sketch shows the model seated in a somewhat typical pose, slightly higher than what might be considered normal eye level. She shows a subtle tilt in her shoulders, with a counterbalancing tilt of the hips and movement of the head. The foreshortening effect of perspective is visible in the legs and, even more markedly, in the lower arm. In the sketches that follow, you'll see the volumes of the figure analyzed in terms of very simple forms so that you can study each to understand its perspective and visualize the perspective of the figure as a whole.

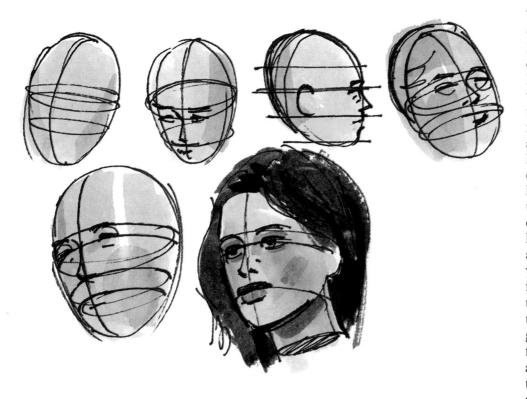

The head is a simple egg shape with center lines that follow its circumference. The line dividing the head verticaly gives you the two equal halves of the form; nose and mouth are centered on this line. The line that divides the head horizontally indicates the position of the eyes. If you divide the lower half of the form again into equal halves you'll find the guideline for the mouth. When the basic egg shape of the head is tilted, the guidelines of course follow the form and tilt as well. This allows you to follow the perspective of the head as a whole when you're drawing the individual features.

Pay special attention to the angle of the shoulders and upper body mass relative to that of the hips and lower body mass. These two areas work in counterbalance to one another. Their relationship animates the torso and gives life and rhythm to the figure. Here, both the upper and lower body masses tilt slightly from the true horizonal. In the upper torso, a slight rotation causes the shoulders to swing closer to the viewer, whereas the hips are farther away. Note that the body masses, like the head shape, is divided by a centerline into two halves. Study the arms and legs separately as simple tubelike forms with various degrees of foreshortening. When the figure as a whole is drawn, these relationships will appear more natural because you've taken the time to understand them.

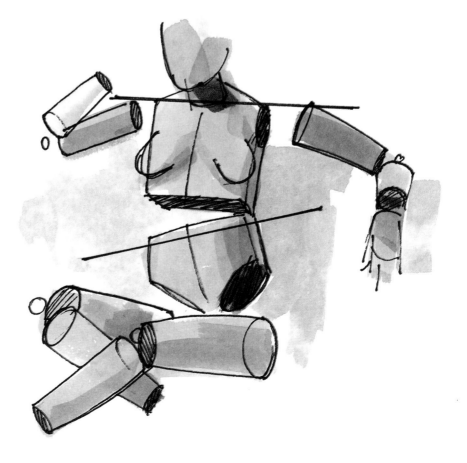

Figure 115

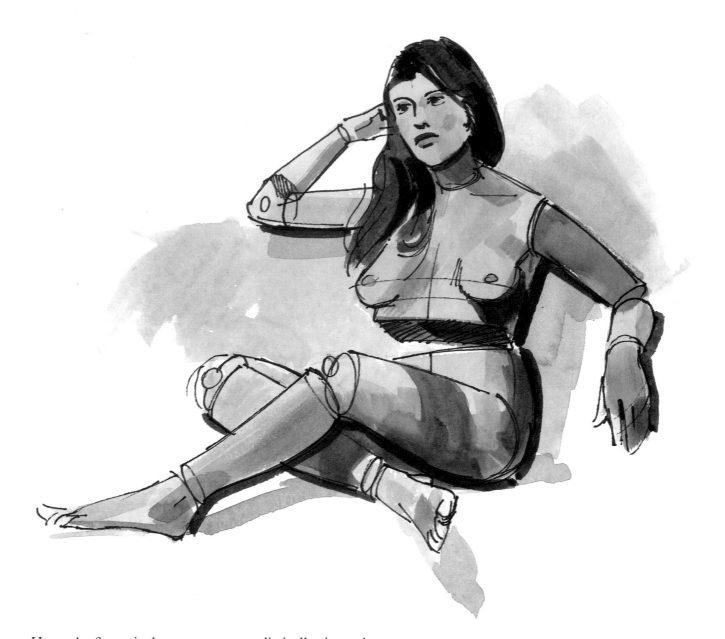

Here, the figure is drawn more naturalistically, its various components assembled in realistic proportion and relationship. We're now seeing the body as a complete form, a volume in space, rather than a collection of simplified shapes. We still use imaginary circles to help us visualize the shapes and perspective of the arms and legs. The guidelines help establish the volumes of the torso. Remember that any guidelines, whether vertical or horizontal, are *never* straight lines; they always follow the curving mass they help define. At this stage, the drawing can be filled with as many guidelines as needed. But draw them unobtrusively so you don't divert attention from the figure as a complete entity. The forms are kept somewhat simple, without much concern for anatomical details; these can be worked into the final painting later.

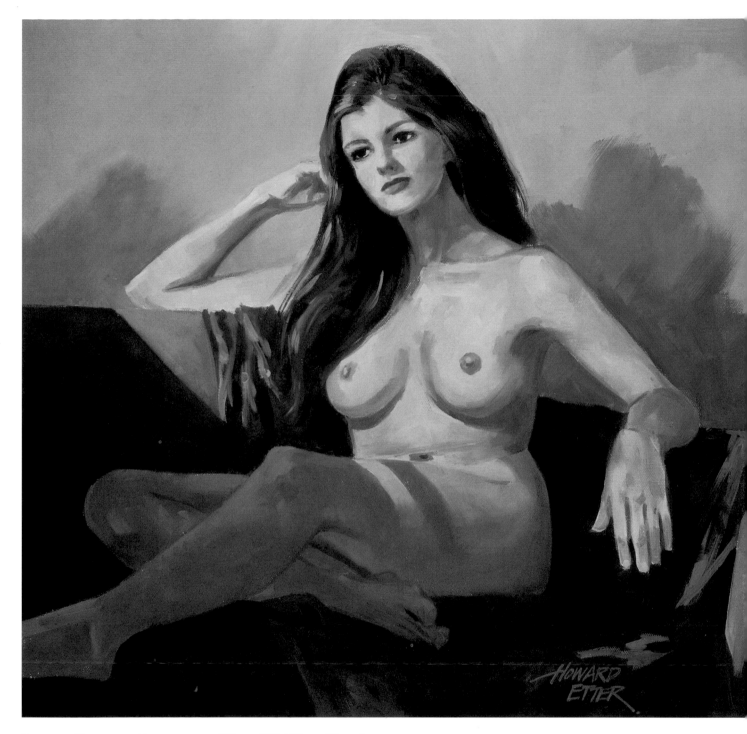

SEATED FIGURE, *oil on canvas, 19" × 20" (48 × 51 cm).*
The finished painting shows further development from the sketches
made from the model. Changes in the light and the cast shadows
increase the feeling of solidity and volume in the form and create
more visual interest. Even though the painting technique is
somewhat loose, the major anatomical reference points, such as the
bones of the ankle and wrist, the knuckles in the hand, the visible
muscles and tendons, have been indicated to show the underlying
structure of the figure and give it a convincingly realistic
appearance.

FIGURE 117

STANDING FIGURE

This standing figure is one of a series of quick ten-minute studies done from the model, who was standing on a low stand that placed the eye level at about shoulder height. Drawn from a closer station point than a full figure would be, this sketch captures a momentary action of the upper torso. The main perspective features are the foreshortening of the arms and the angles of the shoulders and the hips. Simple lighting provides good cast shadows for a clear definition of the forms.

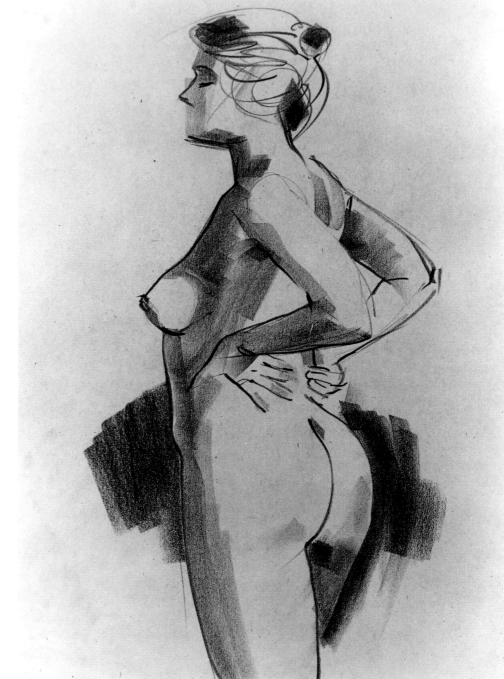

With the head held erect, in profile, the perspective effect is somewhat minimal, but careful drawing of the features will convey the impression that the head is slightly above the viewer's eye level.

The arching of the back forces the shoulders back and the ribcage out, and it tilts the pelvis back. Drawing the simple mannequin shapes will help you understand the movement and the hidden perspective of these two main body blocks. The simplified tube shapes aid visualization of the perspective of the arms as they are thrust out from the arching back. A slight rotation of the hips places them at a different angle from the shoulders.

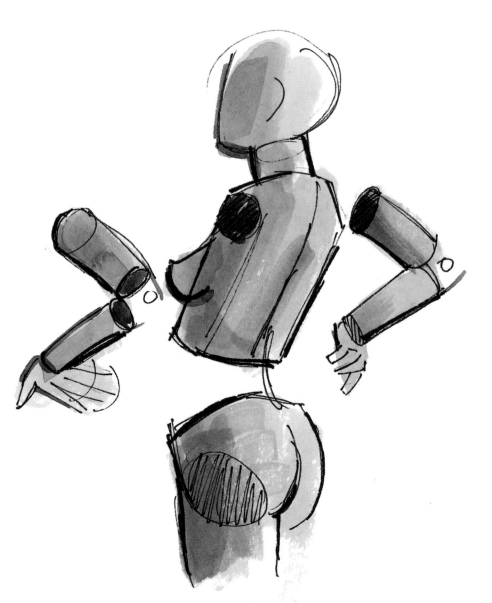

FIGURE 119

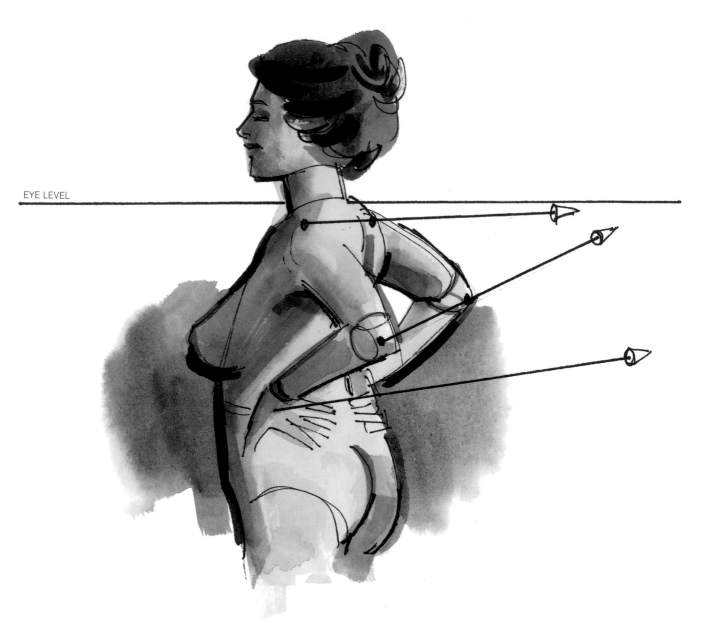

The drawing is further refined in preparation for the painting process by fine-tuning the size, shape, and position of the figure's limbs and masses. The closer viewpoint gives different perspective impressions, which can be seen quite well in the arms. The size change from near to far, and the angles of upper arm to lower arm, are not only visual elements of the pose but also definite perspective cues, which reveal the distance from the figure to the viewer. From a greater viewing distance, the size change between the arms would be minimized, and the visual impression of distance from the observer would be increased. The perspective angles across the tops of the shoulders and the points of the elbows give a good indication of the artist's eye level.

STANDING FIGURE, *watercolor, 20" × 28" (51 × 71 cm).*
In this finished painting you can see that the figure masses have
been kept simple. Some changes have been made in the light
and the cast shadows. The drawing of shapes and edges has
been refined to create a realistic effect and the perspective
references—eye level, foreshortening, overlapping of forms—that
were developed in the preliminary sketches have been incorporated.
The watercolor technique used for this figure tends to flatten the
depths within the picture format and to minimize volumes, but light
and shadow and perspective cues help to retain the sense of realism.

FIGURE 121

RECUMBENT NUDE

This is another typical twenty-five-minute sketch, with the model in a half-seated, half-reclining position. The eye level is near the model's shoulder height. This pose exhibits more twisting and turning of the torso, a tilted and turned head, and visible foreshortening in the arms and legs. The lighting provides a feeling of volume, but it can be altered or manipulated to give more interesting shadow patterns.

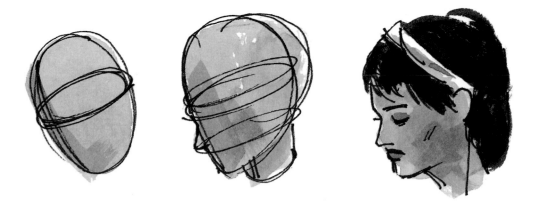

The simplified forms of this pose make it possible to understand the perspective involved. The tilting and turning of the head presents different problems that are best studied separately. Not only is the head tilted downward, but it is also tipped toward the observer.

The two large volumes of the torso are roughed out as simple shapes to show the twisting and tilting of the forms before the arms and legs are drawn. Important perspective cues come from the angular relationship of the two main body blocks, the lines through the shoulders and elbows, and the foreshortening of the legs.

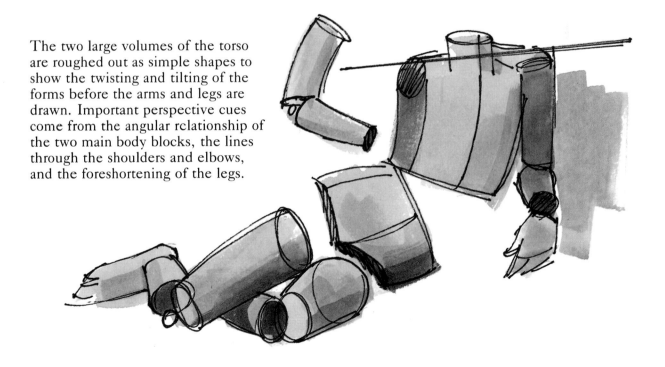

FIGURE 123

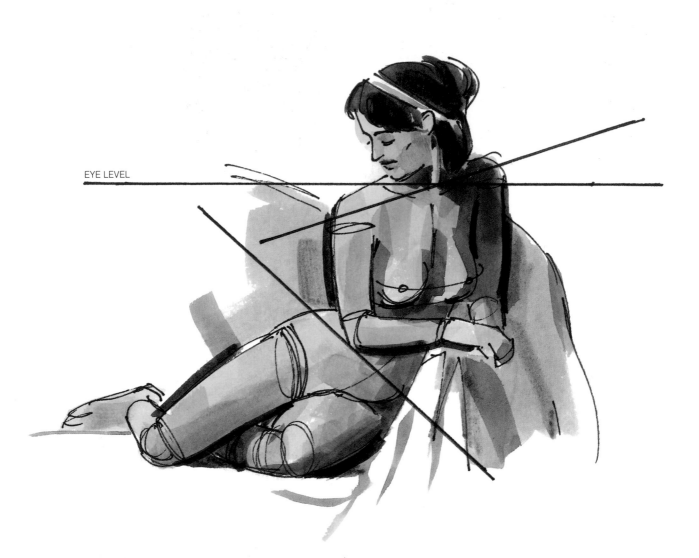

EYE LEVEL

At this stage, the simple tubes and blocks of the mannequin form can be modified to give a more realistic effect. Retain some of the simplicity and structural guidelines to suggest volume and to help in locating secondary features. The placement of the breasts on the curved ribcage, for instance, is facilitated by an elliptical guideline drawn around the ribcage form, just as curved guidelines on the head help locate the eyes, ears, and so on. This simplified drawing invites you to experiment with light and shadow to emphasize volume and perspective and for compositional development.

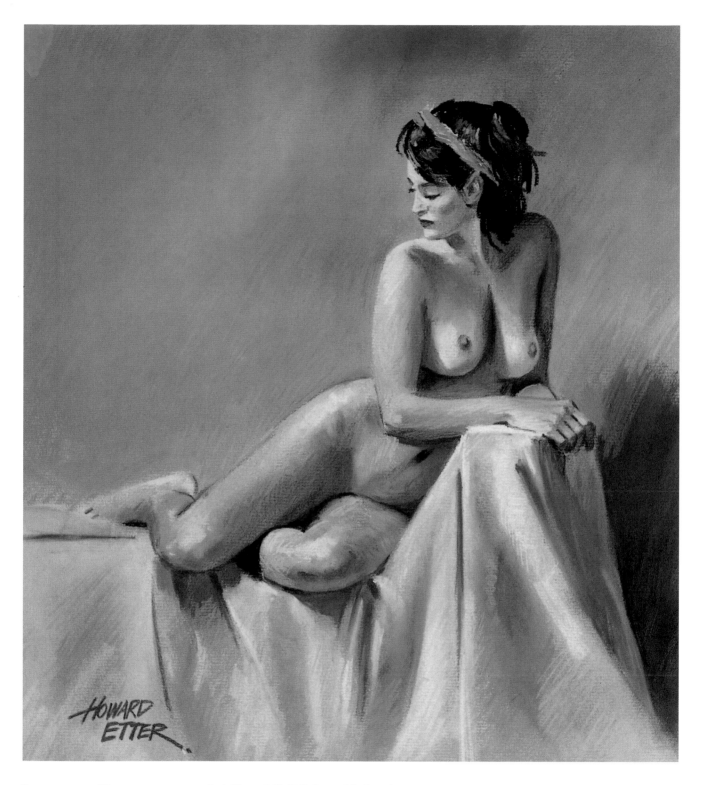

SALLY WITH HEADBAND, *pastel, 14" × 16" (35.5 × 40.6 cm).*
As in the previous demonstration, this figure study has developed in
a series of stages from preliminary sketches from the model,
beginning with studies to understand the perspective of
foreshortening of the forms, to more finished drawings, and a final
painting. Changes and adjustments have been made at each stage
but always within the frame of reference of the basic forms and the
perspective involved.

FIGURE 125

Seven

SHORTCUTS AND HELPFUL HINTS

In this chapter, we'll cover a few mechanical systems that can be applied to freehand work in order to quickly and accurately locate centers and reference lines, project heights, divide spaces, and duplicate intervals. Obviously, these systems will give the most accurate results if you use a straightedge to draw your lines, but even if you use your eye alone, you should find them helpful. We'll also talk about how to "box-in" a nonlinear shape and look at the special characteristics of reflections.

DIAGONALS

Many perspective shortcuts are based on the corner-to-corner diagonal of a square or rectangle. The point at which a pair of diagonal lines cross locates the exact center of the form, which allows us to draw accurate vertical and horizontal centerlines. There are many useful applications of this simple space division in perspective because what is true of a geometric form as a flat surface is also true when that form is projected into perspective view.

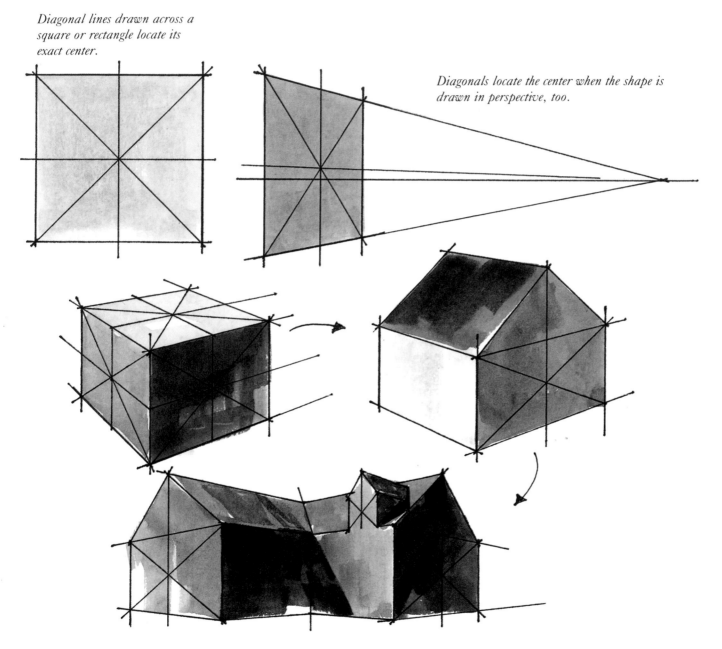

Diagonal lines drawn across a square or rectangle locate its exact center.

Diagonals locate the center when the shape is drawn in perspective, too.

Diagonals subdivide forms and find centerlines to aid in locating structural details, such as roof gables, etc.

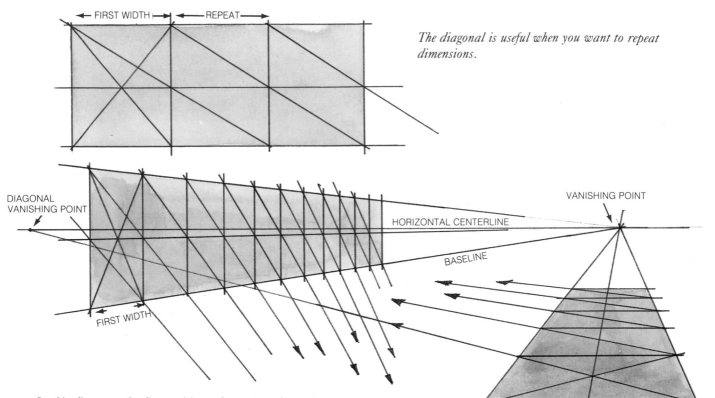

FIRST WIDTH — REPEAT

The diagonal is useful when you want to repeat dimensions.

DIAGONAL VANISHING POINT

VANISHING POINT

HORIZONTAL CENTERLINE

BASELINE

FIRST WIDTH

In this diagram, the diagonal is used to repeat dimensions in perspective. First, choose the initial width by eye, then mark its diagonals and find the centerline, which continues to the vanishing point. Draw a diagonal from the near top corner of the shape through the vertical line that has been established for the width, at its point of intersection with the horizontal centerline, and continue it until it hits the baseline. This provides the reference point for the next vertical, which will mark off the next width. This process can be repeated as needed.

The same system works on the ground plane and can be used to repeat floor patterns or to develop scale relationships on the ground. Notice that the diagonals converge in a vanishing point.

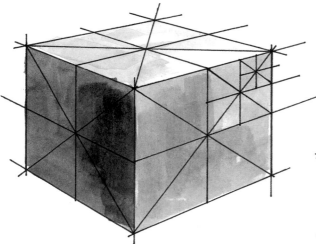

Diagonals allow smaller and smaller reductions to be made easily. Each reduction will be one-fourth the size of the previous one.

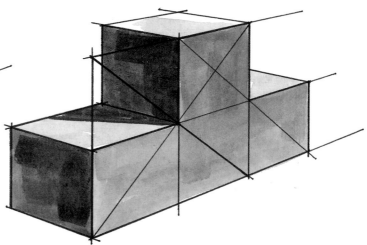

You can start with one box, and by using the diagonal, you can make others exactly the same size in any direction.

VERTICAL REFERENCE LINE

Using a vertical reference line allows us to project nonregular divisions or intervals onto a wall or other surface. When your building (or other object) is drawn in perspective to your satisfaction, proceed as follows:

1. Erect a *vertical reference line*, of any convenient height, at the front corner. (This line need not be the same height as the object; a short or a tall line will work equally well as long as the intersections at the diagonal are easy for you to read.)

2. Mark out *divisions*, starting with those intervals closest to the observer, at the top of the reference line, with the most distant end of the wall at the bottom.

3. Draw a *diagonal* from the top of the reference line at the front corner to the baseline at the back corner.

4. Project *marks* on the reference line to the diagonal, then drop (or raise) this intersection vertically.

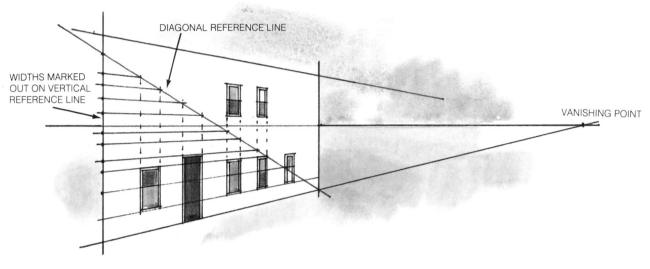

SPECIAL VANISHING POINTS

A special vanishing point allows you to project heights from one part of a composition to another. Any useful height reference can be projected by drawing a line from the base of the known height reference to a new position on the ground plan and continuing it until it intersects the eye level/horizon line, thus locating a special vanishing point for the two positions. Any number of new positions can be selected, and with each, a new special vanishing point will be required.

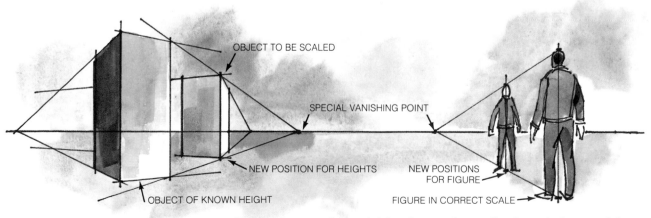

Starting from any known height reference, draw a line from the bottom of the known height through the new position on the ground plane to the eye level to locate the special vanishing point. The line from the top of the known height to the special vanishing point establishes the new height.

GROUND LINE AND MEASURING POINT FOR SINGLE SURFACES

A workable space-division system that can be used for walls or sides of objects involves using a ground line and an auxiliary vanishing point called a *measuring point*. After you've roughed in your wall—or whatever surface you want to divide—and have established its length and its angle to the picture plane, proceed as follows:

1. Draw a horizontal *ground line* across your paper that just touches the bottom of the front corner of your wall. Either rough in or measure out the intervals you need along this line, starting at the near corner and working toward the far end.

2. Draw a line from the end of the scale on the ground line to the point where the far end of the wall intersects the perspective baseline. Continue this line to the eye level/horizon line to locate the *measuring point*.

3. Draw each point on the scale to the measuring point to produce *perspective depths* at the baseline of the wall.

Remember, you must first choose the width or depth of the surface you wish to divide. A shorter or longer scale will move the measuring point to a different spot, but the surface will still be subdivided in keeping with its perspective depth. If your results are unsatisfactory, you may have to reestimate the perspective depth of the surface. By relocating the measuring point, you can use the ground-line scale to subdivide the new wall depth.

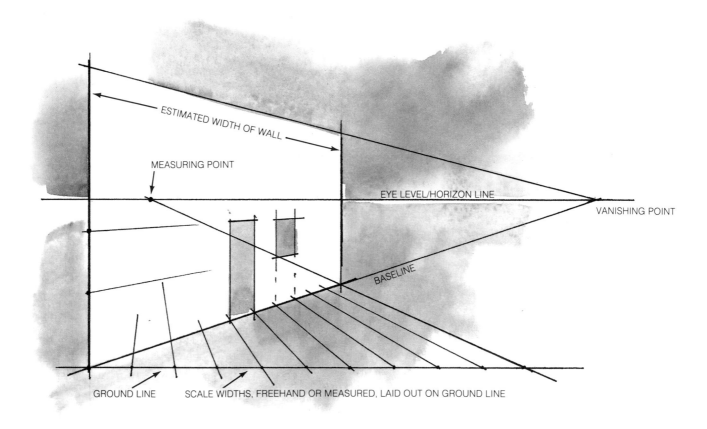

ESTIMATED WIDTH OF WALL

MEASURING POINT

EYE LEVEL/HORIZON LINE

VANISHING POINT

BASELINE

GROUND LINE SCALE WIDTHS, FREEHAND OR MEASURED, LAID OUT ON GROUND LINE

GROUND LINE AND MEASURING POINTS FOR COMPLETE OBJECTS

This system is a more complete and accurate version of the previous ground-line method, but it's still flexible enough to fit the needs of the freehand artist. By locating the measuring point in its proper relationship to the station point/vanishing point spacing, it will provide accurate proportions between the heights and widths for the overall volumes. In other words, you won't have to guess at the width of your subject. As before, the vertical scale, ground-line scale, and measuring points are used to project units of measurement to the shape drawn in perspective. When you've blocked in your main forms well enough to know where your vanishing points will be located, proceed as follows:

1. Measure from the vanishing point for the wall (or other surface) to be divided, to the station point. (If you don't know where your station point is, see below.)

2. Now lay out the same measurement along the eye level/horizon line from the wall's vanishing point toward the opposite vanishing point. This locates the *measuring point* for that surface. Repeat the process from the opposite vanishing point to find the measuring point for the other wall.

3. As in the previous ground-line system, lay out a horizontal *ground line* just touching the bottom of the front corner of your object on which to mark off the dimensions you wish to project in perspective to the shape you've drawn. These dimensions should be measured at the same scale used for the heights.

4. Project the widths (or depths) to the measuring point, located as in Step 2. Where these lines intersect the baseline of the wall, you'll find reference points for any features or divisions that you'll need.

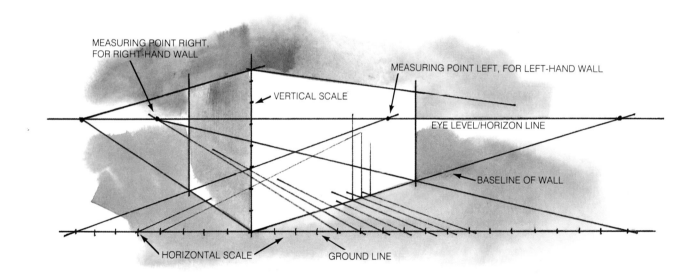

MEASURING POINT RIGHT, FOR RIGHT-HAND WALL

MEASURING POINT LEFT, FOR LEFT-HAND WALL

VERTICAL SCALE

EYE LEVEL/HORIZON LINE

BASELINE OF WALL

HORIZONTAL SCALE

GROUND LINE

Finding the station point

If in Step 1 of this system you realize that you don't know where the station point is, you can find it by making a small-scale sketch of the setup as follows:

(a) Measure the distance between your vanishing points and divide by two or four to give you a convenient scale for your sketch.

(b) On a separate worksheet, draw a horizontal straight line to represent the *picture plane*.

(c) Lay out your *vanishing points* at the reduced scale.

(d) On your full-size drawing, measure from one vanishing point to the approximate center of your subject. Reduce this dimension and transfer it to your small sketch.

(e) In the sketch, drop a *straight line* from the center of the subject perpendicular to the picture-plane line.

(f) Find the midpoint between the vanishing points, and use this as the point from which to inscribe a half circle from one to the other. Your *station point* is located where this arc intersects the centerline of the subject. With your station point located, you can now continue from Step 1.

An advantage to the above method is that you can rough out your shapes and vanishing points the way you want them to be and then check your freehand work to see if your proportions are in the ballpark. If you find that your drawing is out of proportion to any great degree, you can change the heights and/or widths until the ratios are closer to reality. If you decide that you prefer your out-of-scale proportions, you can simply draw from the end of your ground-line scale, past the end of the object, to the eye level/horizon line to establish an alternative measuring point. After all, these systems are not meant to interfere with your artistic judgment but to help you make things look more convincing in your work.

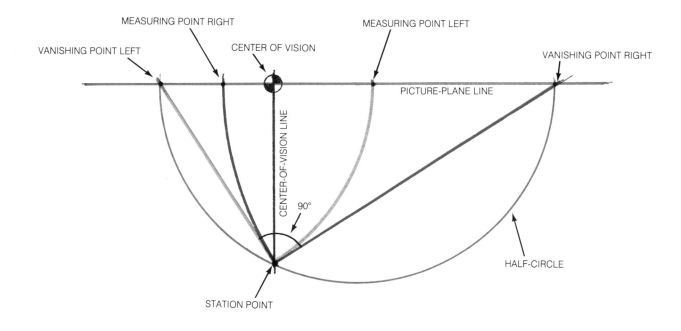

BOXING-IN FORMS

Complicated objects—such as cars, trucks, trains, boats, even airplanes—can be more easily understood and drawn in perspective if their overall shape is "boxed-in," much as if the object were inside a transparent shipping crate. This device helps the eye to visualize the form in terms of its simple mass and to understand its angle and position. Drawing vertical and horizontal centerlines on all faces of the box can help you locate the form within. And it sometimes helps to sketch in a plan view of the object on each face of the box so that you can better visualize the way in which the various surfaces fit together. These sketches, of course, should be done as auxiliary studies. Boats can be especially tricky because of their curving lines. Make separate sketches of forms as seen straight on from the side, front, and back, and in plan view from above.

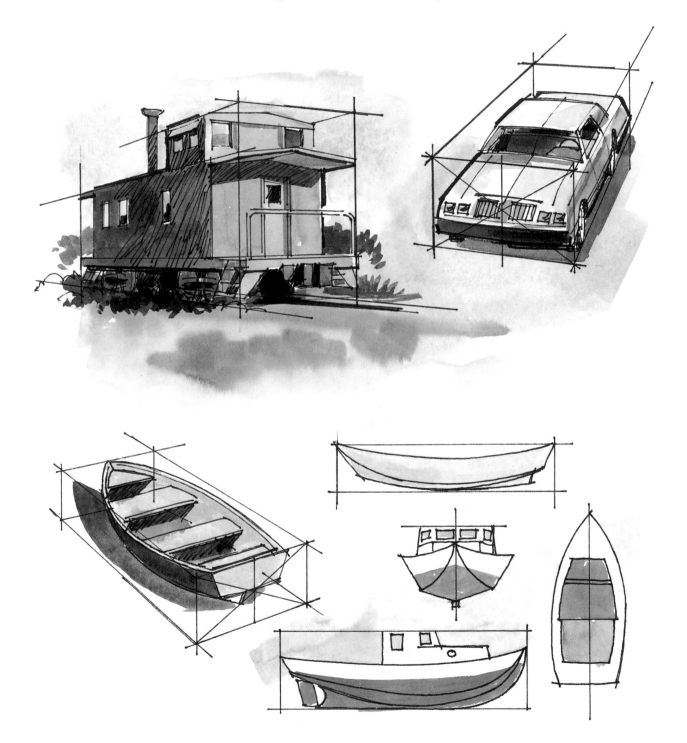

REFLECTIONS

Reflections can provide useful perspective cues, animate and add interest to a composition, and reinforce the impression of depth in your painting. Reflections in still water behave the same way that reflections in a mirror or on any flat reflective surface do. There are two factors that govern reflections on a flat surface: (1) The position of the reflecting surface relative to the subject being reflected. You need to know where the reflecting surface would "cut" the subject if the two were extended until they intersected. It helps to draw this line on or around your subject, even if drawing it means continuing your subject's verticals into the ground in a sort of basement level. This reference line provides the level from which the reflected heights will be scaled. And (2) the fact that the height or length of a vertical *above* (or *outside*) the reflecting surface will be exactly duplicated *below* (or *inside*) that surface.

When painting reflections on choppy water or on any other broken surface, the reflection will of course be broken up by the individual wavelets or bits of surface, which cause the reflected verticals to grow longer. Just how long to stretch the reflections will depend on the surface, the angle of view, and your own perception and judgment.

Note that the reflected image has a different perspective from the subject, even though the horizontals converge to the same vanishing points. The reflected image shows the subject as if it were seen from well below rather than straight on.

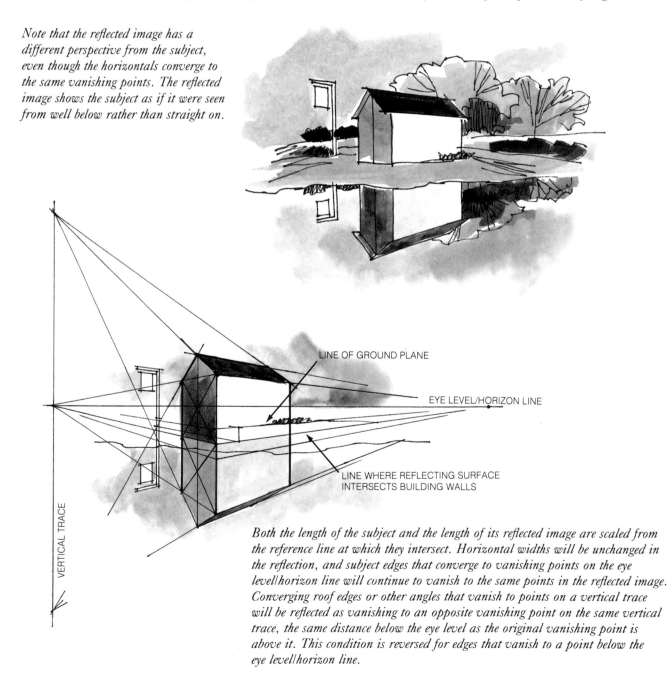

LINE OF GROUND PLANE

EYE LEVEL/HORIZON LINE

LINE WHERE REFLECTING SURFACE INTERSECTS BUILDING WALLS

VERTICAL TRACE

Both the length of the subject and the length of its reflected image are scaled from the reference line at which they intersect. Horizontal widths will be unchanged in the reflection, and subject edges that converge to vanishing points on the eye level/horizon line will continue to vanish to the same points in the reflected image. Converging roof edges or other angles that vanish to points on a vertical trace will be reflected as vanishing to an opposite vanishing point on the same vertical trace, the same distance below the eye level as the original vanishing point is above it. This condition is reversed for edges that vanish to a point below the eye level/horizon line.

Eight
MECHANICAL SYSTEMS

We offer the following mechanical systems for plotting one-point and two-point perspective, for the dedicated beginner as well as for the advanced student. We encourage you to work these systems out with drafting tools, using simplified plans and elevations, many times over and from various angles and eye levels. This kind of concentrated effort will open your eyes, improve your imagination, and give you a lot more freedom in your work.

ONE-POINT "OFFICE METHOD" PLAN PROJECTION

This system is commonly used in architects' offices. A perspective view is projected from the ground plan (plan view) of a building, object, or interior space, relative to the observer's station point. In one-point plan projection, as with any one-point system, two faces (front and back) of the subject are parallel to the picture plane, while the other four (right and left sides and top and bottom) are perpendicular to it; *one* of the three sets of edges goes back in space to converge in *one* vanishing point.

1. Position the plan view of what you want to draw so that one face is flat up against the picture plane. This will give you your two faces parallel to the picture plane and four faces perpendicular. Indicate the *picture plane* with a horizontal line drawn across the bottom of the plan view.

2. Draw another horizontal line, at any convenient distance below the plan view, to establish the *eye level/horizon line* of your perspective view.

3. Indicate your *main line of sight* by drawing a vertical line down through the center of the plan, through the eye level and beyond. The point at which this line crosses the eye level/horizon line will be the *vanishing point* for all lines perpendicular to the picture plane. This point is also the *center of vision*.

4. Find the *station point* by moving the apex of a 60-degree angle (which is a comfortable field of vision for one-point perspective) down the main line of sight (away from the subject) until the entire plan area is included within the triangle.

5. Draw *lines of sight* to the station point from various key points within the plan view, and mark where they cross the picture plane.

6. Extend the left and right walls of the plan view down across the eye level/horizon line to serve as your *scale height lines*.

7. Using the same scale as you used for the plan view, measure *down* from the eye level/horizon line to establish the *floor/ground plane* for the perspective view. This gives you the height of the eye above the ground plane.

8. Again, using the same scale, measure *up* from the floor/ground plane to establish the *ceiling* and other heights.

9. Measure the scale heights of objects at the front edge of the side wall and project them to the vanishing point.

10. Find the positions of the verticals where the lines of sight penetrate the picture plane. (Reference marks drop down as verticals into perspective view.)

11. Project the heights of the verticals from height references on the side or back wall.

12. Objects not parallel to walls in the plan view can be given reference lines on the walls by extending the object's edges to the walls.

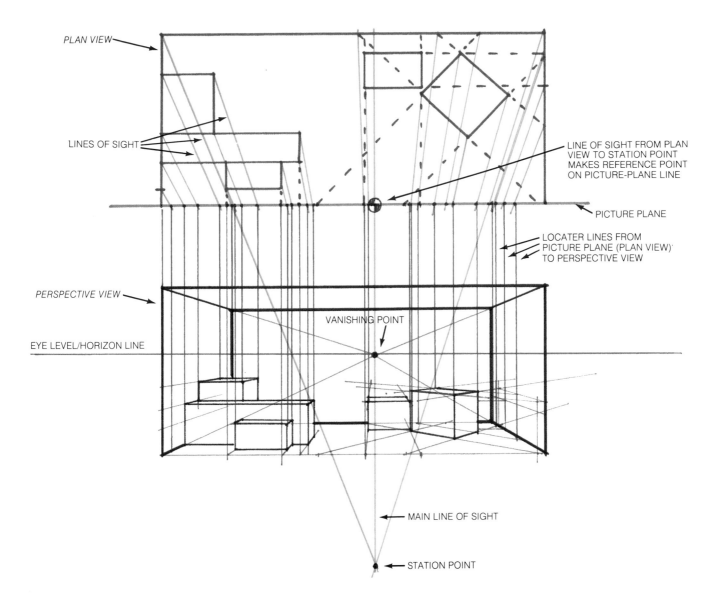

PLAN VIEW

LINES OF SIGHT

LINE OF SIGHT FROM PLAN
VIEW TO STATION POINT
MAKES REFERENCE POINT
ON PICTURE-PLANE LINE

PICTURE PLANE

LOCATER LINES FROM
PICTURE PLANE (PLAN VIEW)
TO PERSPECTIVE VIEW

PERSPECTIVE VIEW

VANISHING POINT

EYE LEVEL/HORIZON LINE

MAIN LINE OF SIGHT

STATION POINT

COLOR KEY

DARK GREEN	PLAN VIEW
LIGHT GREEN	LINES OF SIGHT
BLUE	PICTURE PLANE
LIGHT BROWN	PERSPECTIVE DEVELOPMENT
DARK BROWN	OBJECTS
ORANGE	VERTICAL REFERENCE LINES FROM PICTURE PLANE TO PERSPECTIVE VIEW

TWO-POINT "OFFICE METHOD" PLAN PROJECTION

In this system, a perspective view is drawn by positioning a plan view of the subject behind (above) the picture plane, at a suitable angle, and projecting lines of sight from the plan through the picture plane to the observer's eye at the station point. In two-point perspective, all the faces of the object are at an angle to the picture plane. One set of edges (usually the verticals) is parallel to the picture plane. The *two* remaining sets of edges (usually horizontal) go back in space, each set converging in its own vanishing point.

1. Arrange the plan view of what you want to draw at an angle (none of the faces parallel to the picture plane) on your worksheet.

2. Drop a vertical line from the approximate center of your subject to represent your *main line of sight*.

3. Locate the *station point* by moving the apex of a 45-degree angle (a comfortable field of vision for two-point perspective) down the main line of sight (away from the subject), until the entire plan area is included within the angle.

4. Indicate the *picture plane* for the plan view by drawing a horizontal line, touching the bottom of the near corner of your subject, to any length right across your worksheet.

5. Draw two lines from the station point to the picture plane, one parallel to the left-hand walls in the plan and the other parallel to the right-hand walls. Your left and right *vanishing points* at the picture plane are located where these lines intersect the picture-plane line.

6. Locate your *eye level/horizon line* at any convenient location below the picture-plane line.

7. Drop vertical locater lines from the vanishing points established on the picture-plane line to the eye level/horizon line to establish your *working vanishing points*.

8. Using the same scale as for the ground plan, measure *down* the main line of sight from the eye level/horizon line to establish the distance you want to use for the height of the eye above ground plane. This point also locates where the front corner of the subject touches the ground plane. From this point, measure *up* to find the heights of the various parts of the subject (in this case, wall, eaves, roof ridge, windowsills, top of windows and doors, etc.).

9. To develop the *perspective view*, draw a line from the bottom of the wall corner to each vanishing point, left and right, then repeat from the top of the wall to the vanishing points.

10. To find the locations of the vertical corners, the end of the wall, window and door openings, draw a *line of sight* from the location of the corner in the plan view to the station point. Where this line crosses the picture plane, mark a reference point and drop a vertical locater line into the perspective drawing to establish the position of the corner (or door, window, etc.).

11. To complete the drawing, relate the horizontal lines drawn to the vanishing points to vertical locations dropped from the picture plane. This will establish your heights. Roof angles and similar sloping forms will require that you find the position and height of each end of the sloping line. Any single angle will establish a vanishing point for all other parallel angles.

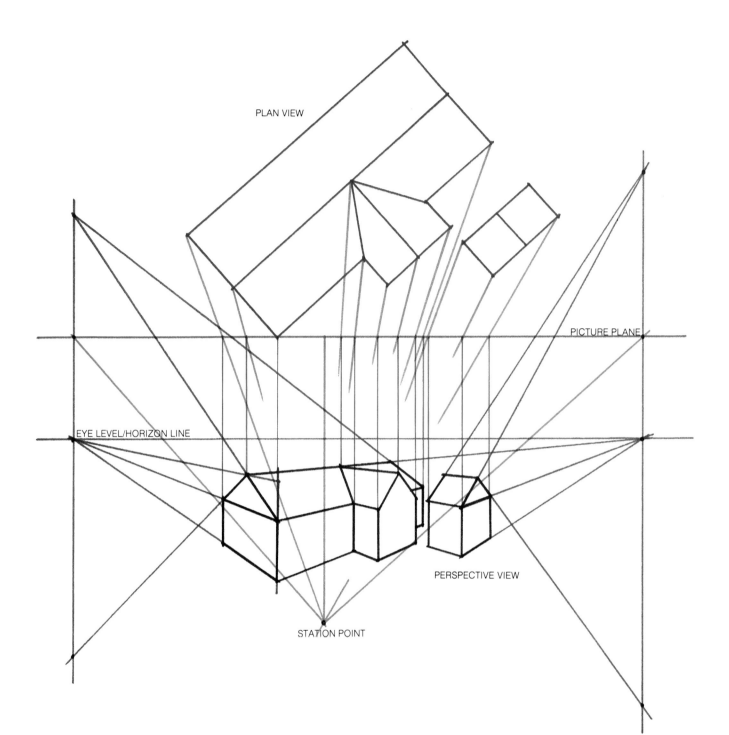

PLAN VIEW

PICTURE PLANE

EYE LEVEL/HORIZON LINE

PERSPECTIVE VIEW

STATION POINT

COLOR KEY

DARK GREEN	PLAN VIEW
LIGHT GREEN	LINES OF SIGHT
BLUE	PICTURE PLANE
LIGHT BROWN	PERSPECTIVE DEVELOPMENT
DARK BROWN	OBJECTS
RED	VERTICAL REFERENCE LINES FROM PICTURE PLANE TO PERSPECTIVE VIEW

TWO-POINT GROUND-LINE PROJECTION

The ground-line method enables you to develop accurate drawing from dimensions only.

1. Draw a horizontal line across your worksheet at any convenient place above center. Place two vanishing points on this line as far apart as is convenient. This will give you your *working vanishing points* located on the *eye level/horizon line*.

2. Divide the distance between vanishing points in half. Use the length of one half to inscribe a half circle between the two vanishing points, below the eye level/horizon line.

3. Decide how far to the left or right of center you want the front corner of your subject (in this case, a building) to be located. From this corner, draw a vertical line down through the eye level/horizon line until it touches the half circle. This point is your *station point*.

4. From the station point, draw lines to each vanishing point and measure the length of each line. Now measure out these lengths on the eye level/horizon line to locate the *measuring points*, as follows: vanishing point left to station point = vanishing point left to measuring point right; vanishing point right to station point = vanishing point right to measuring point left.

5. Draw a 45-degree angle—with its apex at the station point—to the eye level/horizon line. This will show you approximately how wide your subject can be drawn without distortion and should be used as a guide to estimate suitable scale heights.

6. Using the scale you've chosen, measure *down* from the eye level/horizon line to establish the desired height of the observer's eye. This point is also the intersection of the bottom of the building corner with the ground plane. From this point, draw a horizontal line from one side of your worksheet to the other. This is your *ground line*.

7. Measure your widths along the ground line, marking useful references for the left and right walls. Begin at the intersection with the wall corner and measure in the same scale used for the verticals.

8. Draw a *baseline* from the building corner to the vanishing points—in each direction.

9. From the scale widths on the ground plane, draw lines to the opposite measuring point (left-hand ground line to right-hand measuring point, etc.). Where these lines cross the building baseline, you'll find reference points for details such as doors, windows, etc. By combining these perspective depth references with scale heights drawn to vanishing points, you'll be able to accurately draw the entire building.

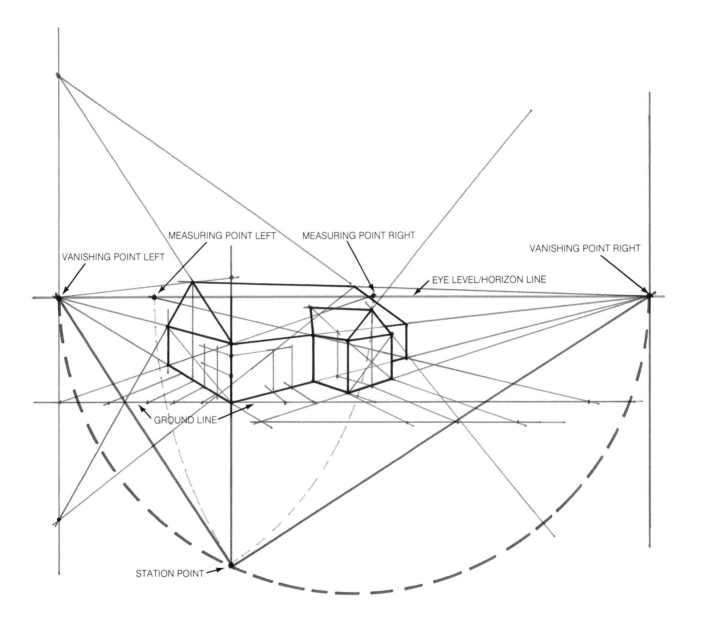

VANISHING POINT LEFT

MEASURING POINT LEFT

MEASURING POINT RIGHT

VANISHING POINT RIGHT

EYE LEVEL/HORIZON LINE

GROUND LINE

STATION POINT

COLOR KEY

DARK GREEN	PLAN VIEW
BLUE	PICTURE PLANE
LIGHT BROWN	PERSPECTIVE DEVELOPMENT
DARK BROWN	OBJECTS

BIBLIOGRAPHY

D'Amelio, Joseph. *Perspective Drawing Handbook*. New York: Van Nostrand–Reinhold, 1984.

Hull, Joseph William. *Perspective Drawing, Freehand and Mechanical*. Berkeley and Los Angeles: University of California Press, 1950.

Lawson, Philip J. *Practical Perspective Drawing*. New York: McGraw-Hill Book Company, Inc., 1943.

Pile, John. *Perspective for Interior Designers*. New York: Whitney Library of Design, 1985.

Schaarwächter, Georg. *Perspectives for Architecture*. New York and Washington: Frederick A. Praeger, 1967.

Walters, Nigel V., and Bromham, John. *Principles of Perspective*. London: Architectural Press; New York: Whitney Library of Design, 1970.

Watson, Ernest W. *How to Use Creative Perspective*. New York: Reinhold Publishing Company, 1955.

INDEX

Edited by Grace McVeigh
Graphic production by Ellen Greene